DHA

Photographs by Jon Ortner

With Sayings of the Buddha

Introduction by Jack Kornfield

welcome
BOOKS

NEW YORK ❖ SAN FRANCISCO

Published in 2003 by Welcome Books®
An imprint of Welcome Enterprises, Inc.
6 West 18th Street, New York, NY 10011
(212) 989-3200; Fax (212) 989-3205
email: info@welcomebooks.biz
www.welcomebooks.biz

Publisher: LENA TABORI
Project Director: ALICE WONG
Designer: GREGORY WAKABAYASHI
Project Assistant: NAOMI IRIE

Distributed to the trade in the U.S. and Canada by
Andrews McMeel Distribution Services
Order Department and Customer Services: (800) 943-9839
Orders Only Fax: (800) 943-9831

Copyright © 2003 by Welcome Enterprises, Inc.
Photographs copyright © 2003 by Jon Ortner
Introduction copyright © 2003 by Jack Kornfield

Library of Congress Cataloging-in-Publication Data on file.
ISBN: 0-941807-28-2

Printed and bound in Japan by Toppan Printing Company, Ltd.
First Edition
10 9 8 7 6 5 4 3 2 1

SOURCES
Anguttara Nikaya, p. 43: from Kerry Brown and Joanne O'Brien
(eds.), *The Essential Teachings of Buddhism* (London: Rider
Books, 1989).

Anguttara Nikaya, p. 123: from Nyanatiloka (trans.), *The Word of
the Buddha* (Kandy, Ceylon: Buddhist Publication Society, 1971).

Anguttara Nikaya, p. 156: from Nyanaponika Thera (trans.),
Anguttara Nikaya: Discourses of the Buddha, an Anthology (Kandy,
Sri Lanka: Buddhist Publication Society, 1975).

Bhaddekaratta Sutta, p. 162: from Thich Nhat Hanh, *Our
Appointment with Life* (Berkeley, Calif.: Parallax Press, 1990).

Dhammapada, pp. 21, 30, 36, 49, 58, 61, 62, 72, 76, 88, 95, 112,
118, 139, 142, 152, 158, 166, 172, 176, 178, 182, 185, 197, 200, 203:
from *The Dhammapada: The Sayings of the Buddha* by Thomas
Byrom, copyright © 1976 by Thomas Byrom. Used by
permission of Alfred A. Knopf, a division of Random House, Inc.

The Gospel of the Buddha, pp. 129, 132: from Paul Carus,
The Gospel of the Buddha (Chicago: Open Court, 1915).

Lalitavistara, p. 220: from William de Bary (ed.), *The Buddhist
Tradition* (New York: Vintage Books, 1972).

Lankavatara Sutra, pp. 23, 186: from Bukkyo Dendo Kyokai
(trans.), *The Teachings of Buddha* (Tokyo: Bukkyo Dendo
Kyokai, 1985).

Mahavagga, p. 68: from T.W. Rhys-Davids and Herman
Oldenberg (trans.), Vinaya Texts, part I, in *Sacred Books of
the East* (Delhi: Motilal Bararsidass, 1968).

Majjhima Nikaya, p. 82: from Christmas Humphreys (trans.),
Wisdom of Buddhism (New York: Random House, 1961).

Majjhima Niyaka, p. 108: from William de Bary (ed.),
The Buddhist Tradition (New York: Vintage Books, 1972).

Metta Sutta, p. 107: from Gil Fronsdal (trans.), *Teachings of
the Buddha*, edited by Jack Kornfield (Boston: Shambhala
Publications, 1996).

Milindapanha, p. 224: from Edward Conze (ed.), *Buddhist
Scriptures* (New York: Penguin Books, 1959).

Satipatthana-sutta, p. 149: from *Thich Nhat Hanh, Transformation
and Healing* (Berkeley, Calif.: Parallax Press, 1990).

Sutta-nipata, p. 211: from E. Max Müller (ed.), *Sacred Books
of the East*, vol. 10 (London: Oxford University Press, 1924).

Therigatha, p. 100: from Susan Murcott (trans.), *The First
Buddhist Women* (Berkeley, Calif.: Parallax Press, 1991).

Vinaya Pitaka, p. 124: from F. L. Woodward (trans.), *Some
Sayings of the Buddha* (London: Oxford University Press, 1925).

Visuddhimagga, p. 219: from Henry Clarke Warren (trans.),
The Gospel of Buddha, edited by Paul Carus (Chicago: Open
Court, 1915).

1. Lotus *(page 1)*
2. 3, & 4. WAT SUTHAT, Bangkok, Thailand *(pages 2–5)*
5. Bagan, Myanmar *(page 10)*
Red numbers indicate images that have additional notes beginning on page 226.

Contents

Foreword

JON ORTNER

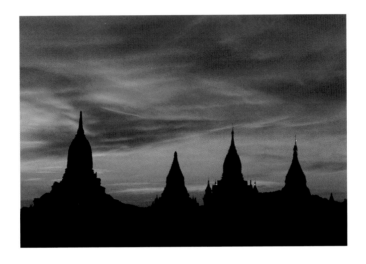

MY FIRST FASCINATION was with the wonders of nature—in particular, with insects. At a very young age I became an avid collector, mostly of *Lepidoptera*, and passionately read and absorbed everything I could on the subject. My curiosity gave me the perfect excuse to venture out on my own, exploring secret places and examining nature's simple marvels. At that time, the late 1950s and early 1960s, Long Island's north shore was changing, its vast estates and farms slowly giving way to subdivisions and suburban sprawl. Some had just been abandoned. I would sneak into these romantic edens, where lawns had become rolling

fields of milkweed, Queen Anne's Lace, and black-eyed Susans. I would walk softly through the English-style formal gardens, whose walls were now crumbling, their fountains silenced, their once carefully laid-out beds overgrown. The air was rich with the scents of wildflower and hay, alive with the buzz of cicadas, the whir of hummingbird wings and the squeaks of chipmunks. I'd come across a box turtle, unearth a spotted salamander, or find a rare butterfly. Every day provided a naturalist's thrill.

As my curiosity grew into a passion, I learned the scientific nomenclature and observational skills needed to accurately identify different species. I discovered that the Linnaean system of categorizing organisms—into Phylum, Family, Genus, and Species—instantly gave not only the exact identification of an animal, but its relation to every other organism on earth. I eagerly studied the scientific disciplines of evolution and cladistics. With this acquired knowledge of the interrelationships of all living things came a vastly enriched understanding and enjoyment of the natural world.

In my teens, my lifelong love of the outdoors was matched by a longing for spiritual knowledge. Like so many before me, I turned to the writings of Hermann Hesse and Heinrich Zimmer, which led me to the work of the Buddhist philosopher D.T. Suzuki, and then to that of Ashvaghosha. While at university, I continued my scholarly pursuits in science and eastern philosophy. Linnaeus's natural order, I sensed, had strong parallel in the enormous structural cosmology of Hindu metaphysics. This realization led me to the Buddhist texts that focused on concepts of self, causation, and impermanence. Yet my interest was that of a young man: active and restless rather than contemplative.

And so I was drawn to India and Nepal by these twin passions—a desire to experience the spirituality embodied in these writings, and the exotic natural world of tropical Asia. The fact that these locations were literally on

the other side of the planet—as far away as I could possibly go—intrigued me. It would be an adventure, a challenge to all that was familiar. But my first journey to the East, in 1971, came with a predictable result: naïve as I was, I was shocked by India's abject poverty, lack of sanitation, and intensely mercenary environment. I had imagined a dreamlike landscape, suffused with spirituality and wisdom. What I encountered instead was just the opposite—crowded, defiled, and decidedly un-holy.

As quickly as I could, I left the cities. I sought out the most spiritually charged sites I could find: the ancient temples, caves, forests, and rivers long held sacred as dwelling places of the gods. And it was at these shrines that I finally felt the sense of holiness and serenity I'd been searching for, and met the yogis and monks practicing lives of contemplation, discipline, and asceticism. The asceticism affected me powerfully: it was my first overwhelming experience of the Buddha nature.

One trip became another, then another. I began to understand the symbolic meaning of Hindu and Buddhist religious art—in which every temple is a representation of the cosmos, transposed to earth to function as a dwelling place of spiritual power and a focal point for the purification of the mind. I learned that every building is a cosmic calendar, every architectural measurement a reference to time, every floor plan a mandala. Moreover, every representation of the Buddha is equally rich with meaning. Every aspect of every image—the position of the body, the proportion of the body parts, the position of the hands, the attire—plays its own role in a language of complex iconography.

Photographing Buddhist art became my window into this world. I especially sought out the art and architecture of the original Theravadin traditions, many of which were still *in situ*—still at the geomantically charged sites that had called them forth. I visited as many holy places as I could,

deciphering the iconography carefully within philosophical and historical contexts. Seeing these symbols worshipped, revered, and sanctified according to traditions that have existed for thousands of years was, for me, like finally witnessing the heart and soul of the culture I traveled so far to find. I wanted not merely to observe the wisdom of these practitioners and the sanctity of these places, but to join the faithful and experience the divine—to feel the contentment of my fellow pilgrims. And while using a camera was my ostensible reason for being there, as my interest in the natural world had been my motivation to wander those Long Island meadows of my youth, so too in these temples I found an inexhaustible source for exploration, experience and, ultimately, love. I came to understand these places and images as direct manifestations of a philosophy that penetrates right through to the very nature of reality and consciousness. For this is a philosophy that attends to the suffering of the human condition, and to our existential loneliness, and that points the way toward compassion and enlightenment.

While creating these images during my twenty-five years of travel throughout Asia, I encountered innumerable challenges and difficulties. Many of the statues, frescos, and carvings are hidden or sequestered, while others are protected by fences and guards. The work has taught me patience. For doors are ultimately unlocked, and gates are opened. And this kind of photography entails aspects of meditation. To wait for exactly the right light and to return time after time to the same place is, in fact, a form of contemplation.

This work was undertaken to preserve and share images that convey the deep spiritual conviction I saw around me, but my experiences have proved extraordinarily enriching. For each encounter with the Buddha is a privilege. It is my fervent wish that these photographs unlock similar doors for all who see them.

J. O., New York City, 2003

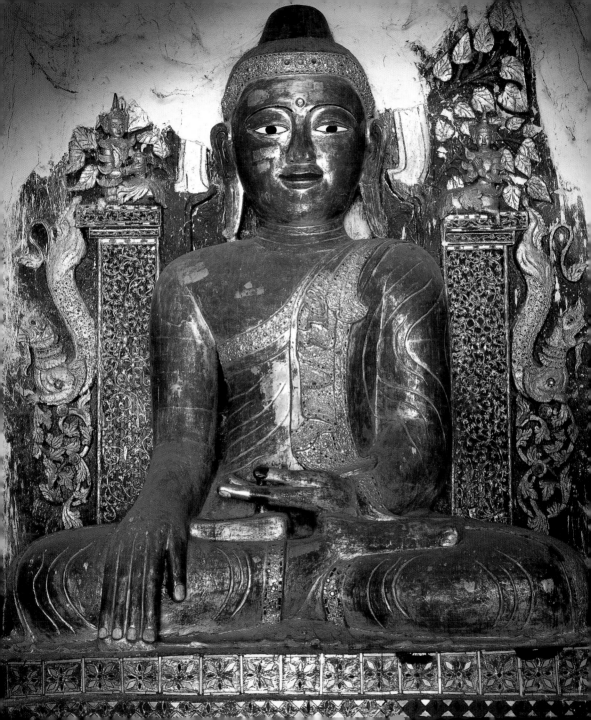

Introduction

JACK KORNFIELD

I T IS SAID that soon after his enlightenment the Buddha passed a man on the road who was struck by the Buddha's extraordinary radiance and peaceful presence. The man stopped and asked, "My friend, what are you? Are you a celestial being or a god?"

"No," said the Buddha.

"Well, then, are you some kind of magician or wizard?"

Again, the Buddha answered, "No."

"Are you a man?"

"No."

"Well, my friend, then what are you?" The Buddha replied, "I am awake."

Buddha means "one who is awake," and the teachings of Buddhism express the Noble Path discovered by the Buddha to lead all beings to awakening. History tells that the Buddha was born a prince named Siddhartha Gotama to a royal family of North India over 2,500 years ago. He was raised in palatial luxury, given every pleasure, and shielded by his parents from the troubles of the world. As he grew older and traveled throughout his kingdom, he became acutely aware of the suffering in human

6. ANANDA PAGODA, Bagan, Myanmar

life. He saw the inevitability of loss, aging, sickness, and death. Then he encountered a yogi who had renounced the world. Deeply affected by what he had seen, at age twenty-nine the Buddha left the palace to becomes a wandering ascetic in the forests of India. He dedicated his life to seeking an answer to the problem of human suffering.

For six years he fasted and undertook an austere struggle, battling against the desires of his own body and mind. But after these years of physical deprivation, he found himself near starvation and no closer to freedom. Searching for direction, he overheard a fisherman teaching a young boy how to play the lute: "When the strings are just right—not too loose and not too tight—only then can you start to make music." Perhaps, Siddhartha considered, there was another path besides the extremes of worldly indulgence or self-denial, a Middle Way—a life of inner and outer balance. Inspired by these thoughts, he seated himself calmly beneath the shelter of a *bodhi* tree and vowed to meditate there until he found an answer. Siddhartha remained in this spot as he faced the forces of human suffering: fear, doubt, temptation, greed, and hatred. Unmoved by every vision that arose before him, he rested with an open heart and a clear mind. Looking deeply into the nature of all existence with understanding and compassion, he discovered true peace, a freedom of heart in the midst of all things. He was enlightened.

For nearly fifty years afterward, he traveled on foot across India teaching the reality of this inner freedom to all who would listen. From the first, he taught the Four Noble Truths, beginning with the Truth of Suffering. He then described the Causes of Suffering: greed, hatred, and ignorance. He taught the Noble Truth of the heart's release from suffering which he called *Nirvana*—cool, inviting and peaceful. And finally, he taught the Noble Truth of the Path to this freedom: the path of virtue, meditation, wise understanding, and compassion.

Everywhere he went, people came to listen to his words. Gradually there grew across India a large, devoted community of followers, monks, nuns, and laypeople of all castes and creeds. The practices and teachings offered by the Buddha, who was also known as the Blessed One and the Happy One, transformed the lives of his devotees.

From the first years, his devoted followers created sacred temples, *stupas*, and pagodas as monuments to the teachings of enlightenment and as resting places for monks and nuns. In the earliest centuries after the founding of Buddhism, there were no depictions of the Buddha himself, only symbols: a wheel, an empty throne, a footprint, a lotus, a deer—all standing in for the Blessed One. This earliest Buddhist art conveyed the stillness and simplicity of the Buddha's Way. As his teachings became more popular, the artistry of its depictions also changed. Several hundred years later, after Greek influences spread across India, the first known Buddha statues appeared. Carved in stone, they look like the god Apollo.

Gradually the seeds of the teachings and practices of the Buddha spread from the middle kingdoms of India to the nearby lands of Afghanistan, Sri Lanka, Myanmar (formerly Burma), and Thailand, and then across China and Japan to all of Asia. As the teachings spread, so did the enthusiasm for the building of sacred temples and *stupas*, and with them came a grand flowering of Buddhist art and architecture. Each of these cultures found its creative gifts, its artists' delight in awakening the heart of the Buddha in a myriad of new forms offered to the ages—all unsigned and selfless.

In *Buddha*, Jon Ortner has artistically and magically captured the breadth of this flowering in 155 images of spirit and devotion, of haunting beauty and serenity. In these images, the Buddha—some recent, some a thousand years old—smiles at us and offers with his hands a gesture of peace. Or he looks at our sufferings with the awakened vision of his third

eye of wisdom and offers a symbol of fearlessness. In the shapes of these pagodas every element—earth, air, fire, and water—is represented in balance, and every tier of the spire symbolizes a higher and more subtle state of consciousness. Each of these *stupas* and gestures and *mudras*, each of the Buddha's varied postures, each illuminated temple and pagoda is filled with the symbolism of awakening. More than that—each is filled with hope. Hope for the awakening of the great heart of compassion in every being who gazes upon them. Hope that we who see them will be inspired to live our days with the unshakable peace of a Buddha.

Often these images and temples shine because they are covered in gold and jewels. To his devoted followers this represents the preciousness of the Three Jewels: Buddha; *Dharma*, the liberating teachings; and *Sangha*, the enlightened community. These Three Jewels are esteemed above all else. Equally symbolic, the untarnishable purity of gold symbolizes the luminous, shining, timeless quality of consciousness itself, our own Buddha Nature, the fundamental purity of every being proclaimed by the Buddha. The gold and jewels of his teachings of peace and compassion shine forth sparkling and illuminating the world.

Entering the temples and sacred shrines in this book depicted by Jon Ortner's photographs offers a sacred journey to the reader. The impact of being in the presence of such symbolic beauty is cooling and calming to the senses. Seeing these Buddhas can be touching and inspiring in a palpable and transformative way. Thomas Merton described such an experience in his last book, *The Asian Journals*. One morning, visiting the ancient Sri Lankan monastery of Polonarua, he walked across a vast, grassy lawn to visit several enormous statues of the Buddha carved into a gigantic marble cliff. To Merton they were almost alive, charged, among the most wonderful works of art he had ever encountered. Looking at the Buddhas, peaceful and open,

he saw "the silence of the extraordinary faces, the great smiles, huge, and yet subtle, filled with every possibility, questioning nothing, rejecting nothing. The great smiles of peace, not of emotional resignation, but a peace that has seen through every question without trying to discredit anyone or anything—without refutation. It is simple. For those who see with the eyes of the Buddha, the whole world arises in emptiness and everything in it is connected in compassion."

It is this awakened and compassionate consciousness that is captured so beautifully in these pages. Alongside the sacred images of these temples and Buddha statues Jon has printed the sacred teachings of the Buddha himself. These words come primarily from the ancient Pali language, the earliest recorded sayings of the Buddha. The ancient stories tell us that when they were first spoken—in dialogue or in an assembly of devoted followers—many of those who listened were enlightened. So turn these pages slowly, listen to these words, read them like a pilgrimage. Let the blessings of the images renew your spirit. And let the Buddha's teachings of truth, of compassion, and of freedom awaken your heart to the freedom and compassion that is your own Buddha Nature.

> May you and all beings
> live with the blessings of compassion
> and a liberated heart.

J. K., Spirit Rock Center, Woodacre, California, 2003

Human Existence

Everything arises and passes away.
When you see this, you are above sorrow.
This is the shining way.

Existence is sorrow.
Understand, and go beyond sorrow.
This is the way of brightness.

Existence is illusion.
Understand, go beyond.
This is the way of clarity.

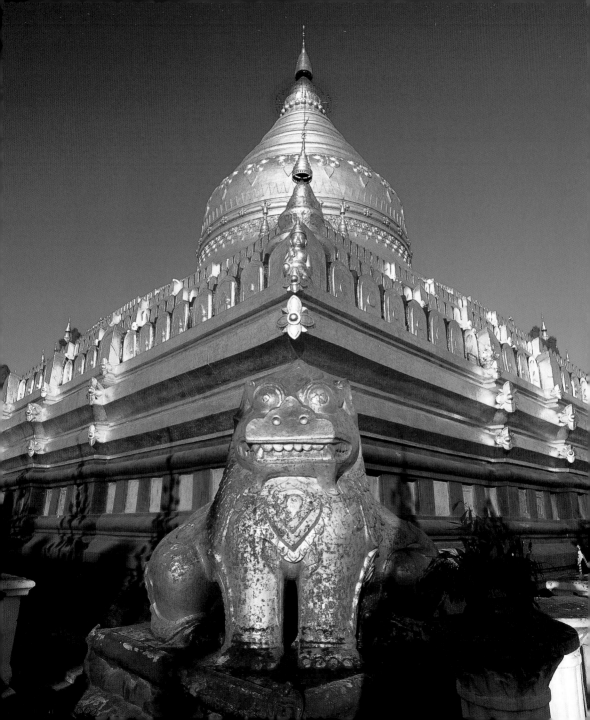

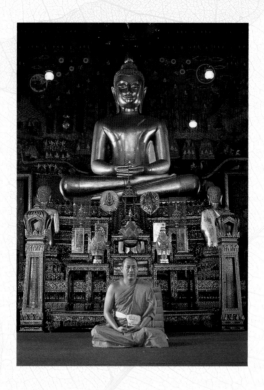

All things appear and disappear
Because of causes and condition.
Nothing ever exists entirely alone;
Everything is in relation to everything else.

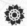

7. SHWEZIGON PAGODA, Bagan, Myanmar *(opposite)*
8. WAT SAKET, Bangkok, Thailand

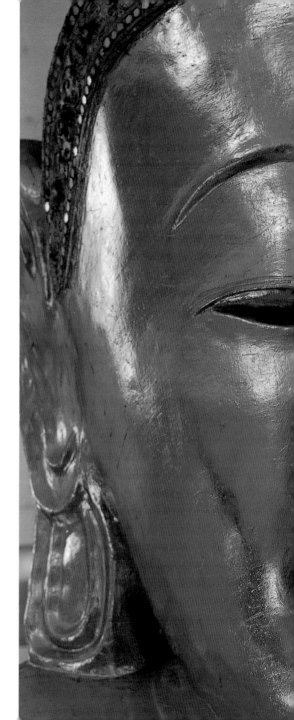

24

9. Nanh Paya, Sale, Myanmar

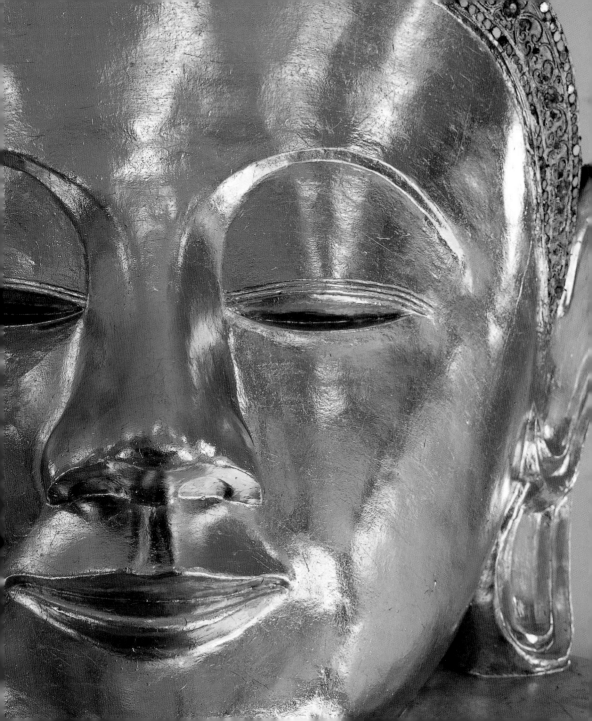

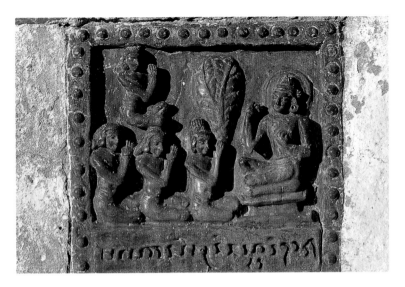

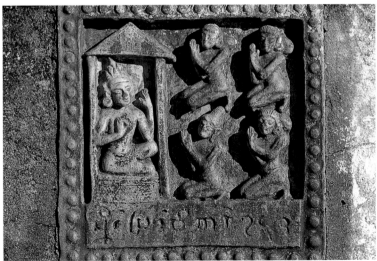

26

10 & 11. *Jataka* plaques, ANANDA PAGODA, Bagan, Myanmar

12. ANANDA PAGODA, Bagan, Myanmar *(opposite)*

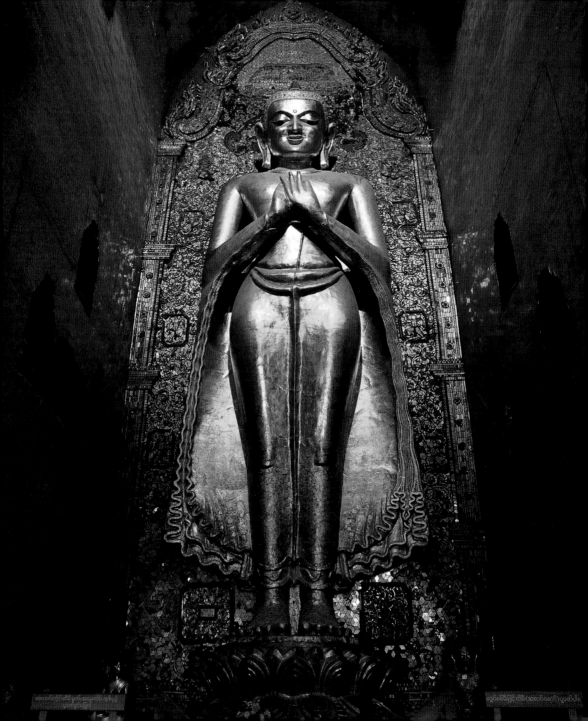

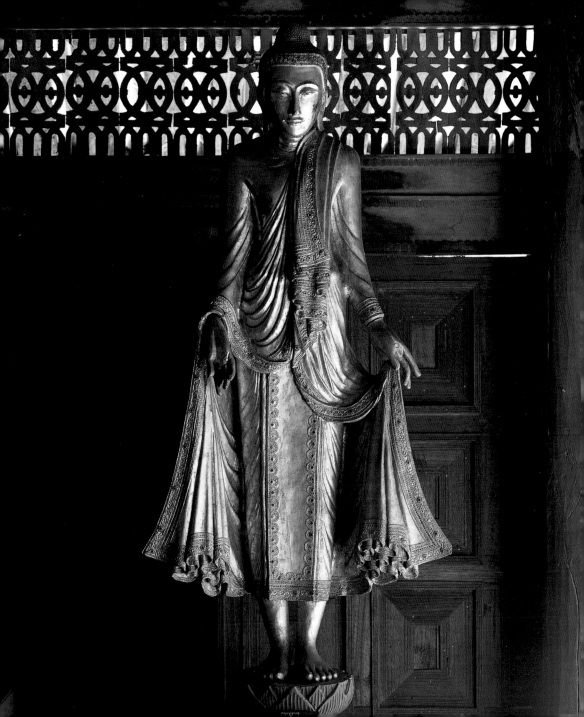

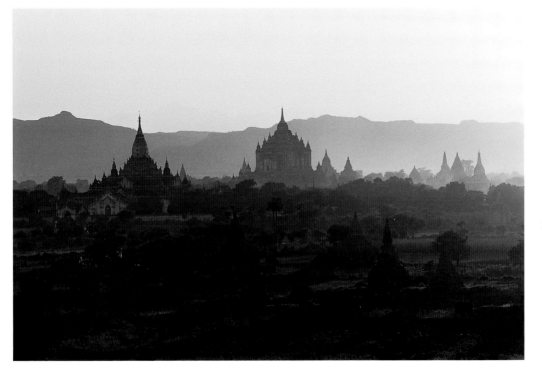

13. YOESOE KYAUNG MONASTERY, Sale, Myanmar *(opposite)*

14. Bagan, Myanmar

Pleasures flow everywhere.
You float upon them
And are carried from life to life.

Like a hunted hare you run,
The pursuer of desire pursued,
Harried from life to life.

❁

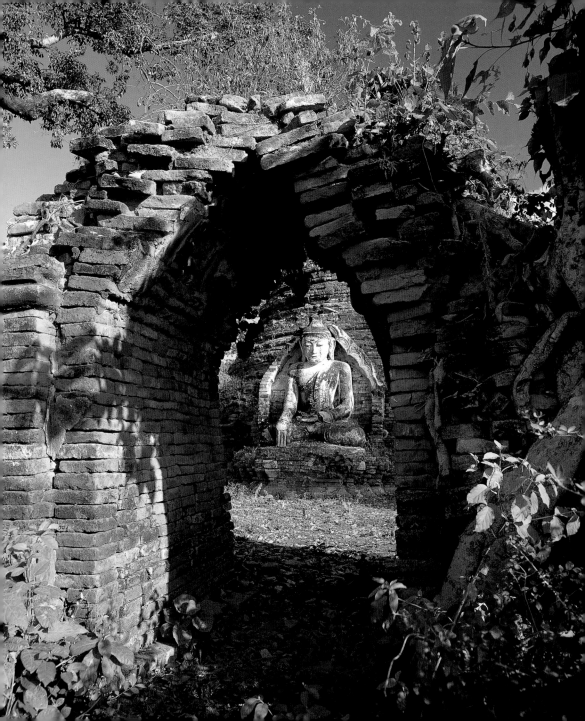

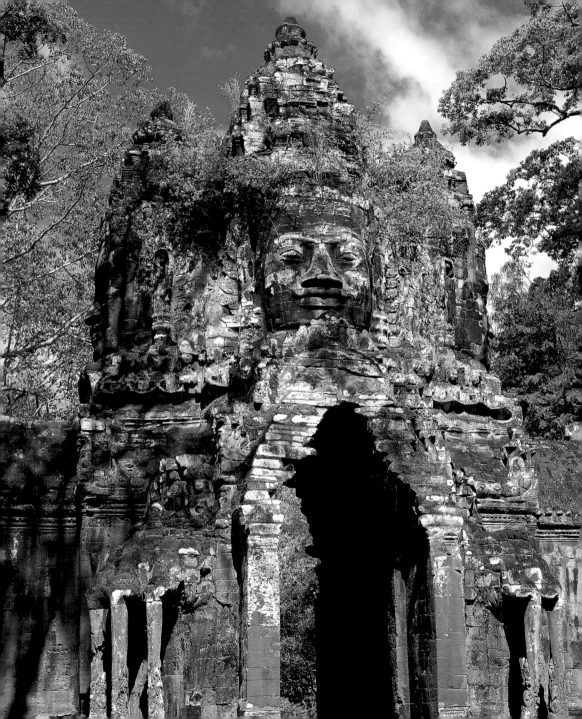

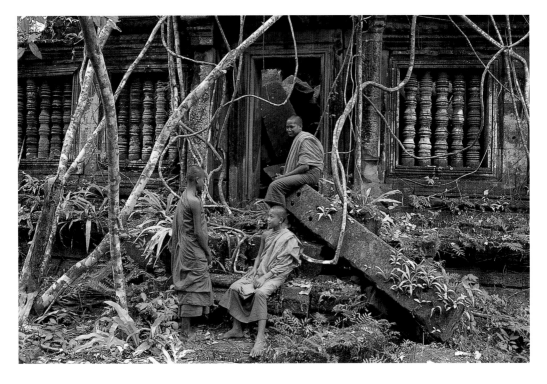

16. North Gate, ANGKOR THOM, Siem Reap, Cambodia *(opposite)*

17. Beng Mealea, Cambodia

18. BAYON, ANGKOR THOM, Siem Reap, Cambodia *(overleaf)*

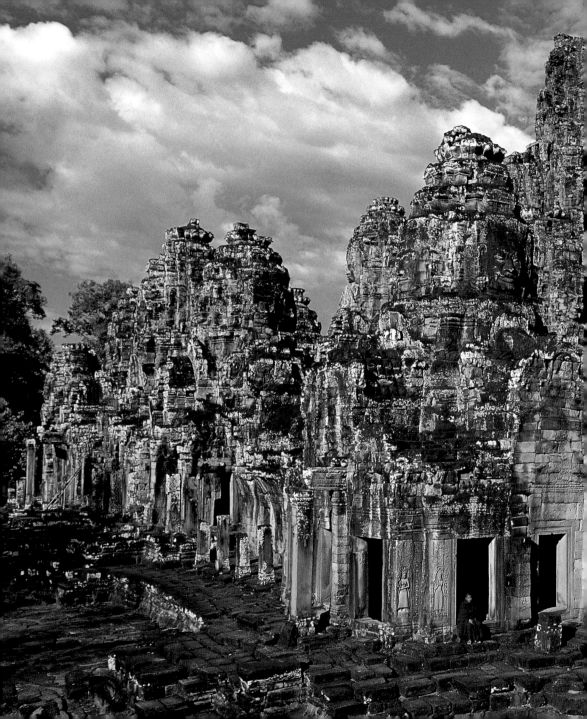

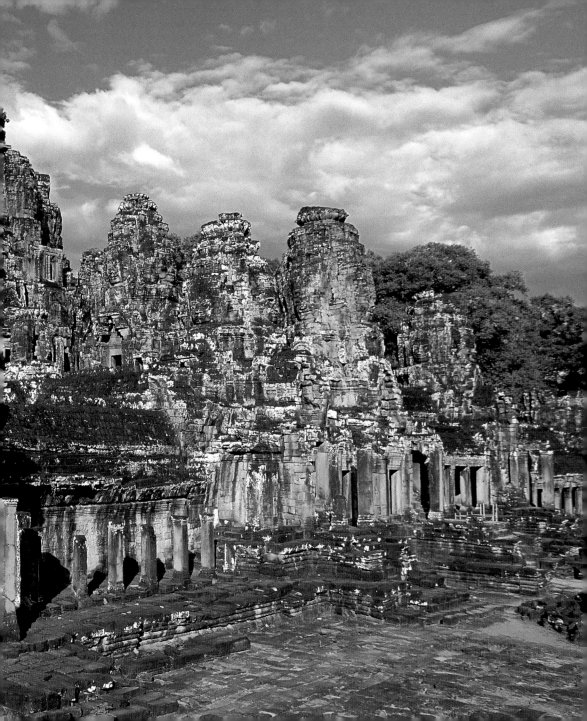

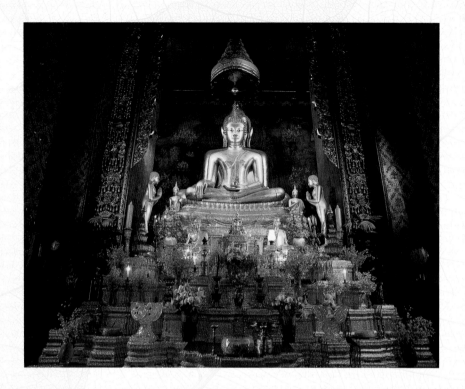

Not in the sky,
Nor in the midst of the ocean,
Nor deep in the mountains,
Nowhere
Can you hide from your own death.

19 & 20. WAT BOWONIVET, Bangkok, Thailand

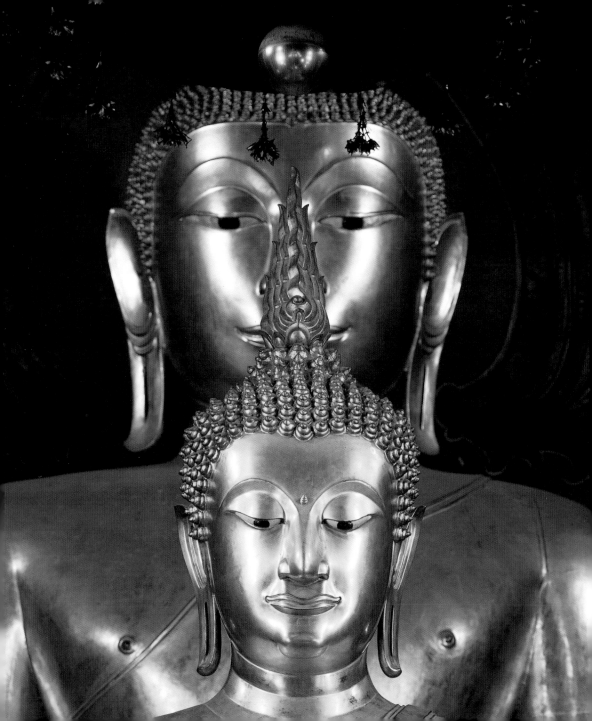

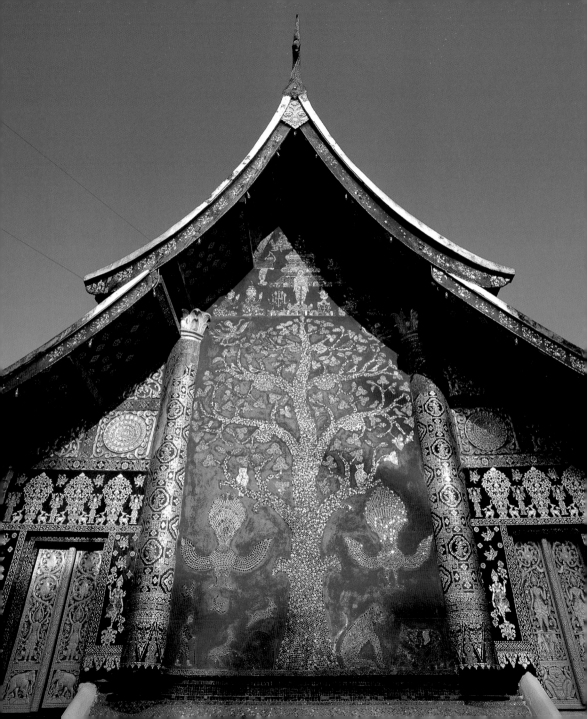

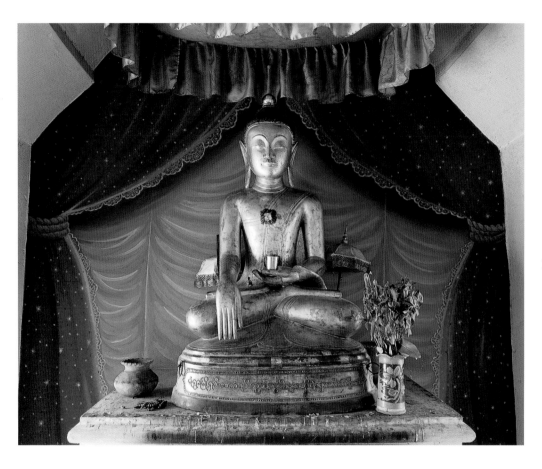

21. WAT XIENG THONG, Luang Prabang, Laos *(opposite)*

22. SHWESIGONE PAGODA, Monywa, Myanmar

40

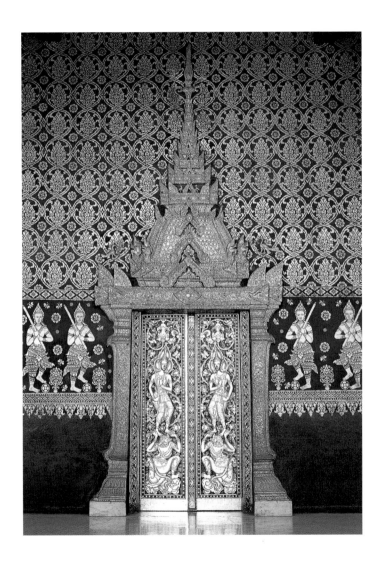

23 & 24. WAT SEN SOUKHARAM, Luang Prabang, Laos

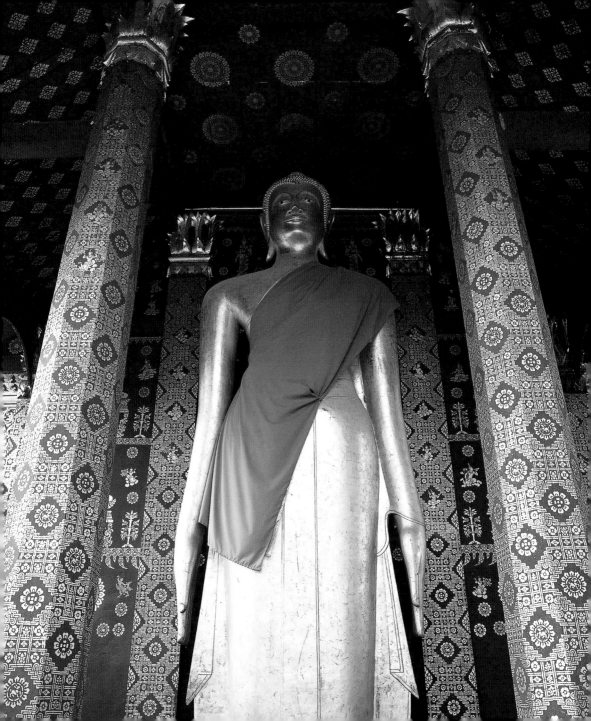

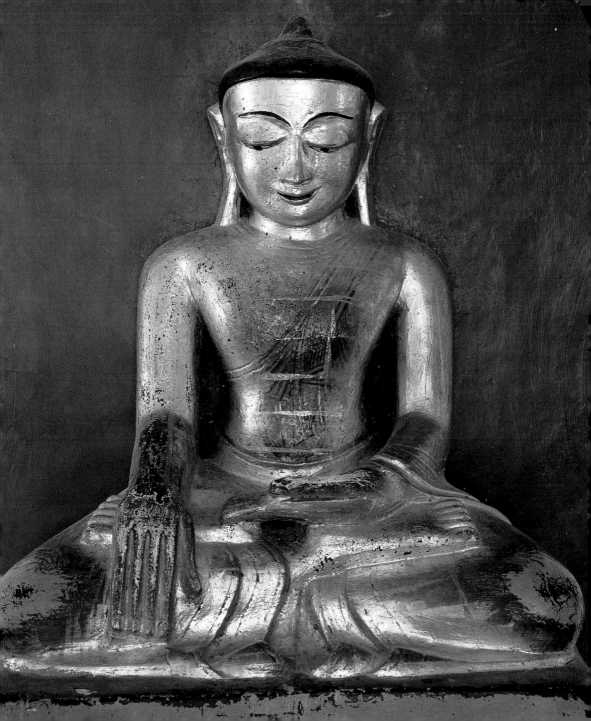

Do not be the judge of people;
Do not make assumptions about others.

25. DHAMMAYANGYI PAGODA, Bagan, Myanmar *(opposite)*
26. Lotus tile, WAT PHRA THAT LUANG, Luang Prabang, Laos

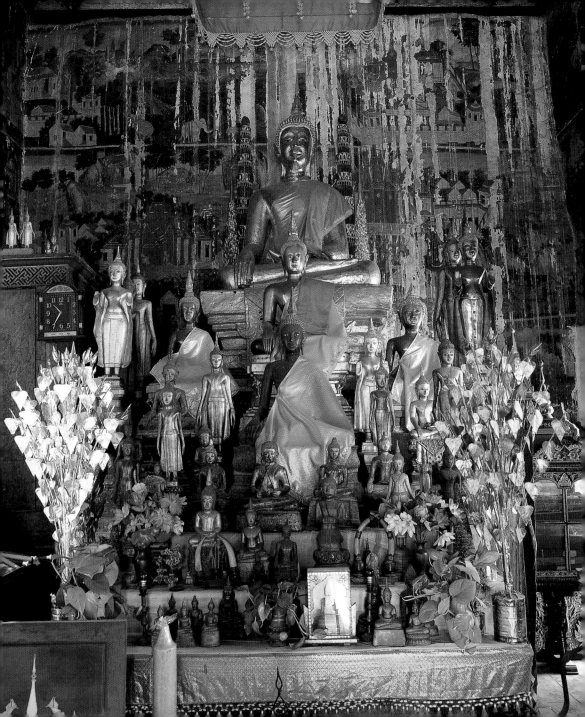

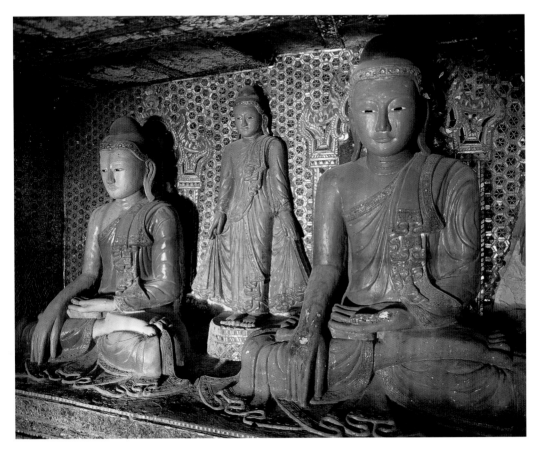

45

27. Wat Si Phoutthabath, Luang Prabang, Laos *(opposite)*
28 & 29. Po Win Daung Caves, near Monywa, Myanmar *(above and overleaf)*

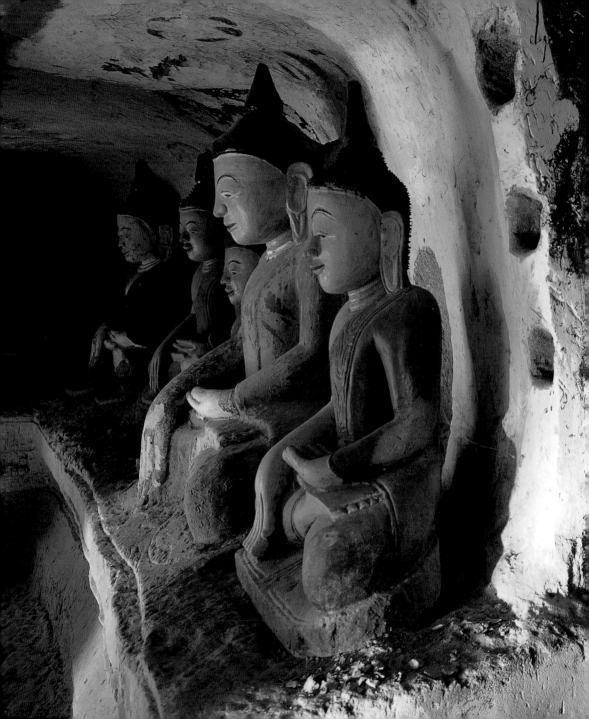

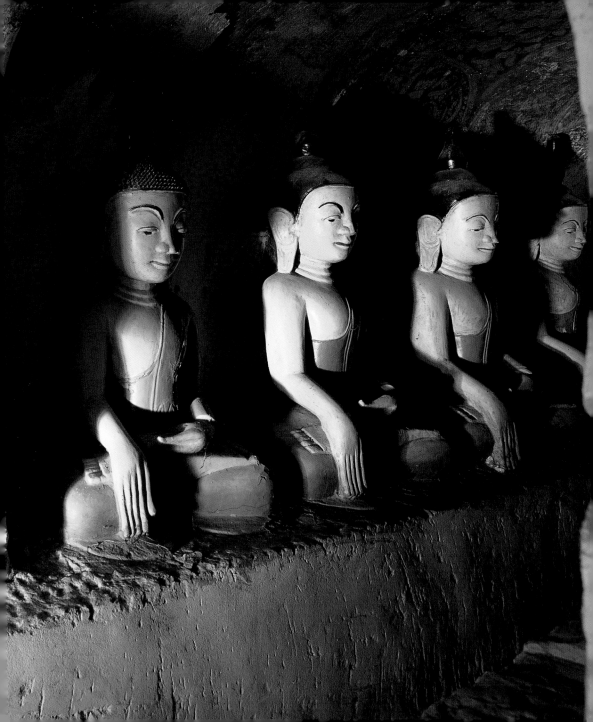

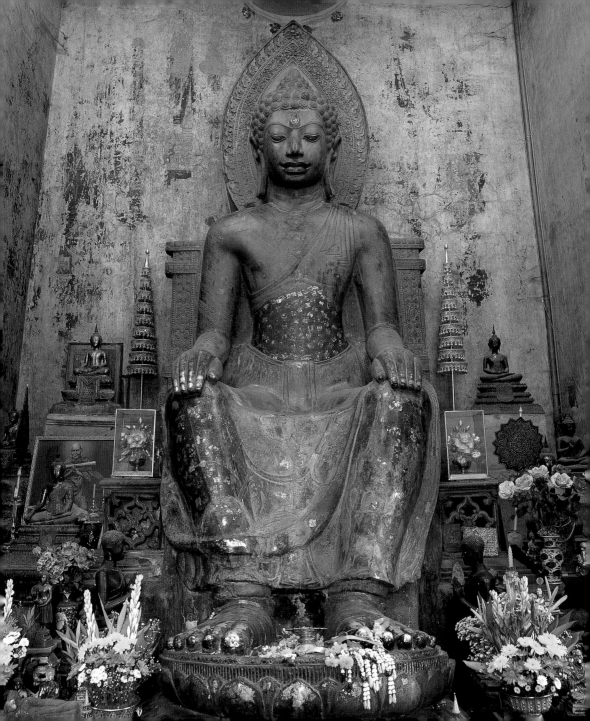

The fool who knows he is a fool
Is that much wiser.
The fool who thinks he is wise
Is a fool indeed.

The fool is his own enemy.
The mischief he does is his undoing.
How bitterly he suffers!

30. *Phra Kantharat*, WAT NA PHRA MEN, Ayutthaya, Thailand *(opposite)*

31. Lotus, Cambodia

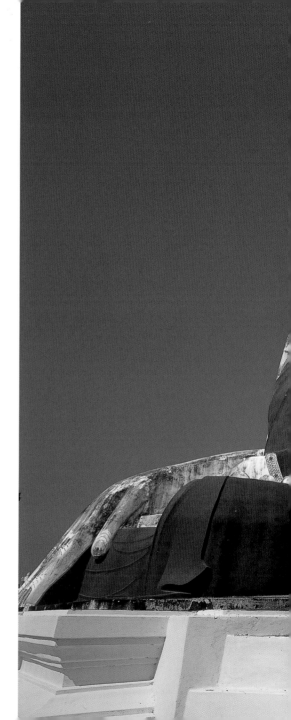

50

32. KYAIKPUN PAYA, Bago, Myanmar

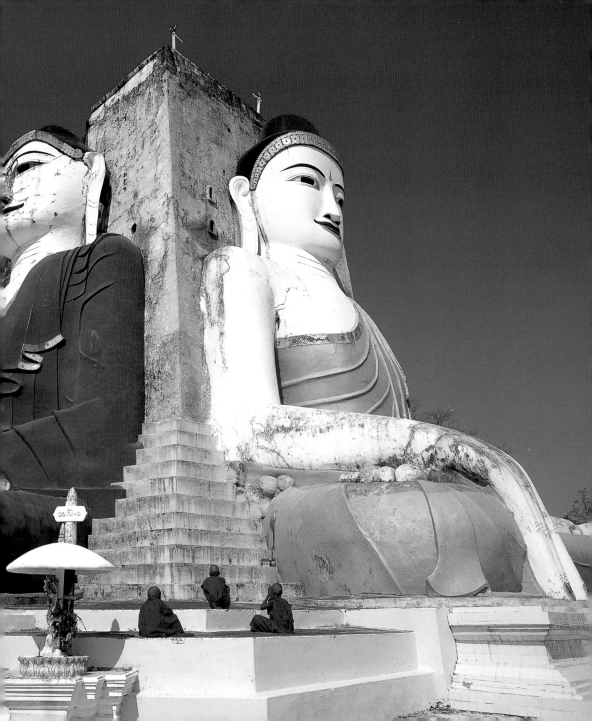

52

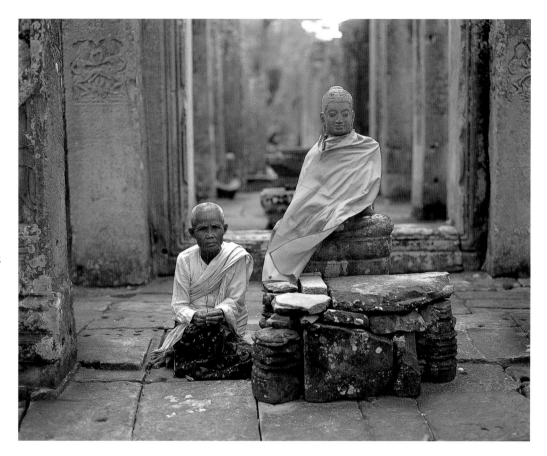

33. Bayon, Angkor Thom, Siem Reap, Cambodia
34. South Gate, Angkor Thom, Siem Reap, Cambodia *(opposite)*
35. Shitthaung Pagoda, Mrauk U, Myanmar *(overleaf)*

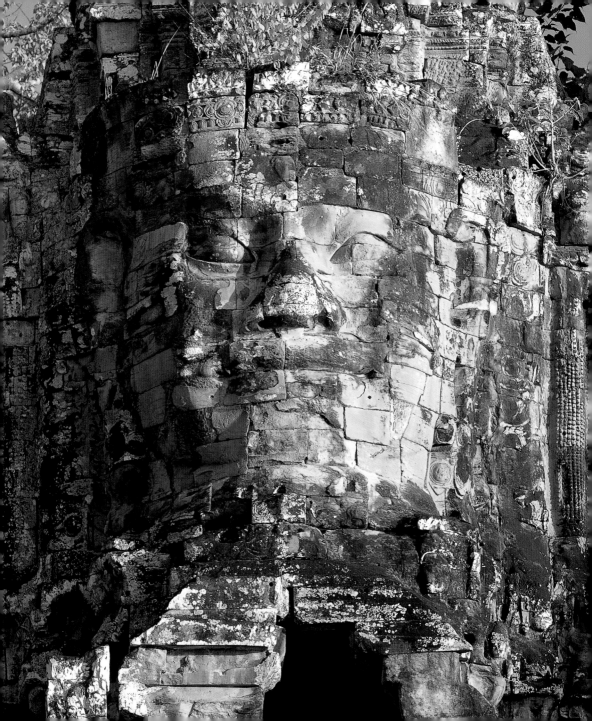

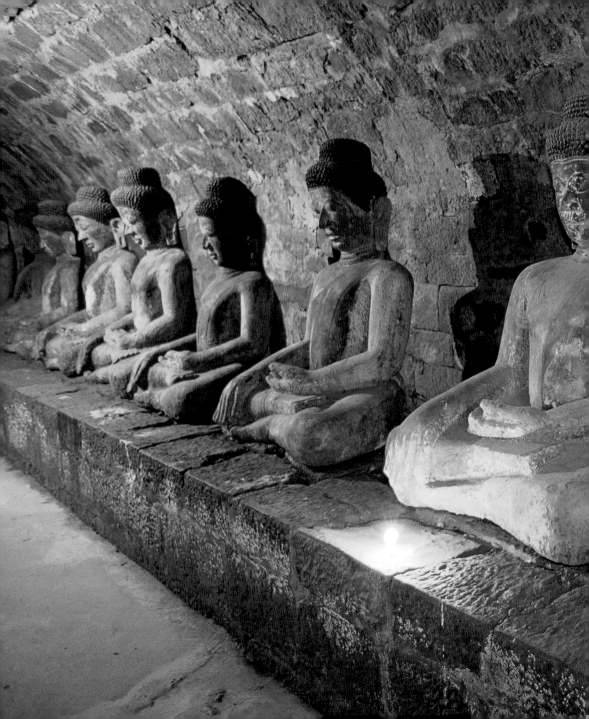

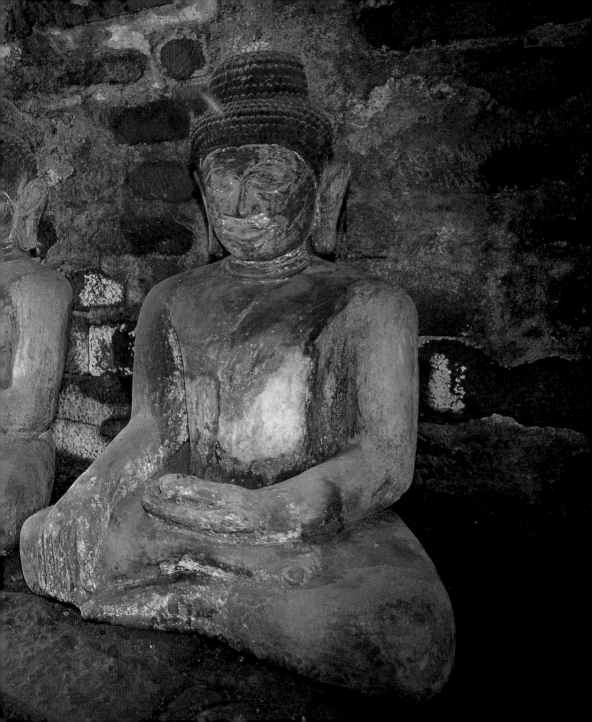

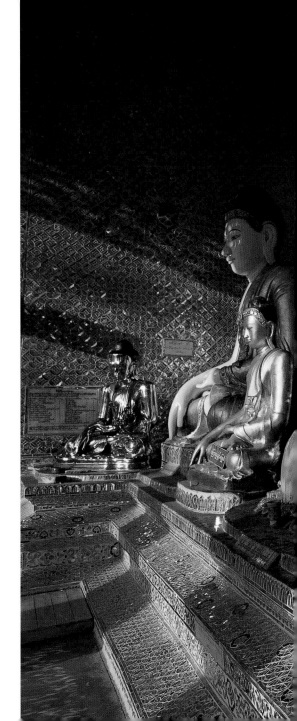

56

36. SHWEDAGON PAGODA, Yangon, Myanmar

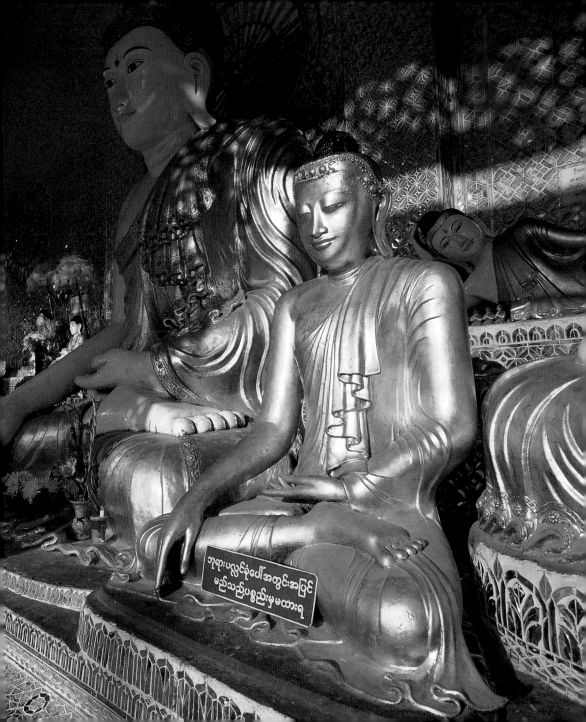

There is no fire like passion,
No crime like hatred,
No sorrow like separation,
No sickness like hunger,
And no joy like the joy of freedom.

37. TAUNGTOO ZEDI, Inle Lake, Myanmar

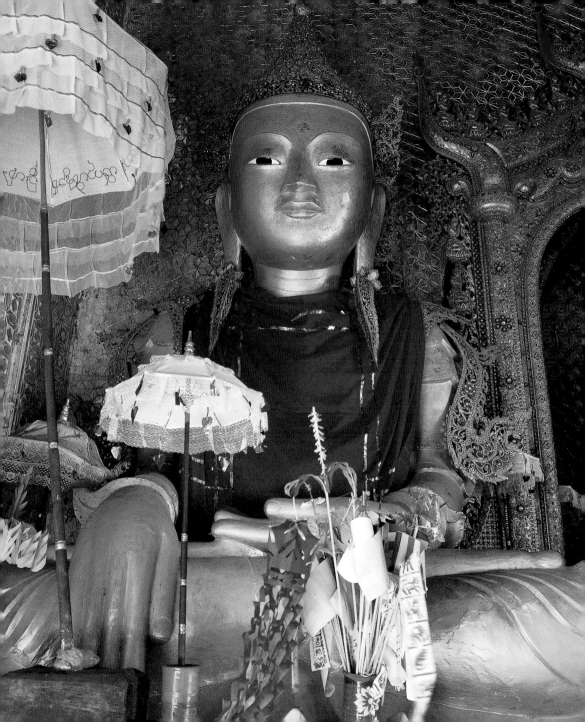

The Path

First establish yourself in the way,

Then teach,

And so defeat sorrow.

To straighten the crooked

You must first do a harder thing—

Straighten yourself.

You are your only master.

Who else?

Subdue yourself,

And discover your master.

If the traveler can find
A virtuous and wise companion
Let him go with him joyfully
And overcome the dangers of the way.

If the traveler cannot find
Master or friend to go with him,
Let him travel on alone
Rather than with a fool for company.

38. SHWEYATTAW, Mandalay Hill, Myanmar

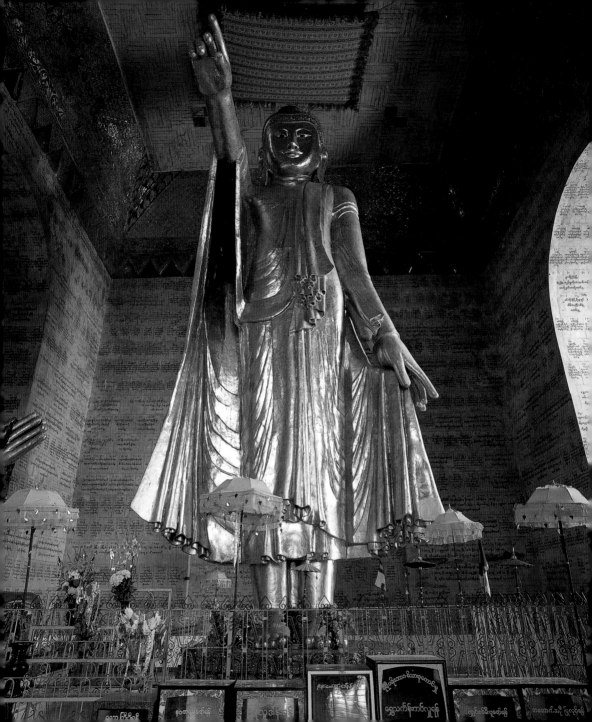

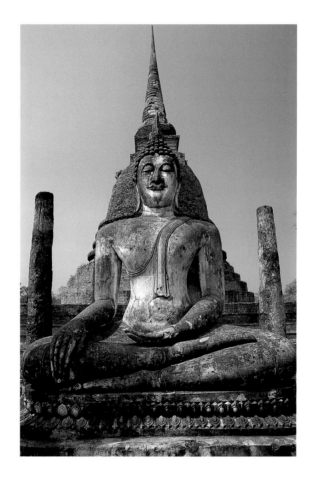

39. On the path to SHWEUMIN, near Pindaya Caves, Myanmar *(opposite)*

40. WAT SRA SRI, Sukhothai, Thailand

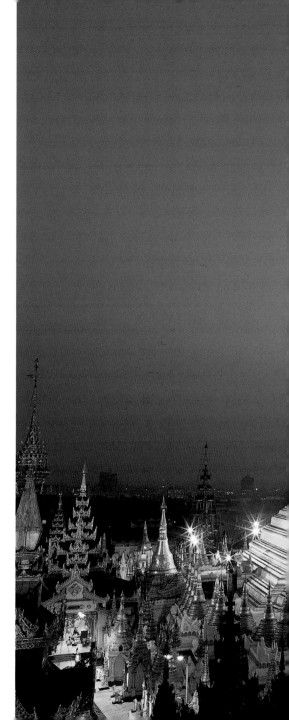

41. SHWEDAGON PAGODA, Yangon, Myanmar

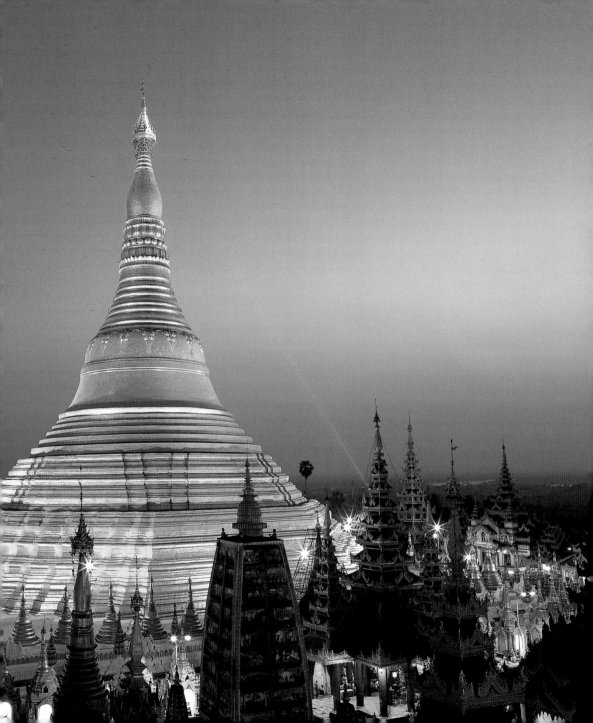

By absence of grasping one is made free.

❀

42. WAT PHRA SINGH, Chiang Mai, Thailand

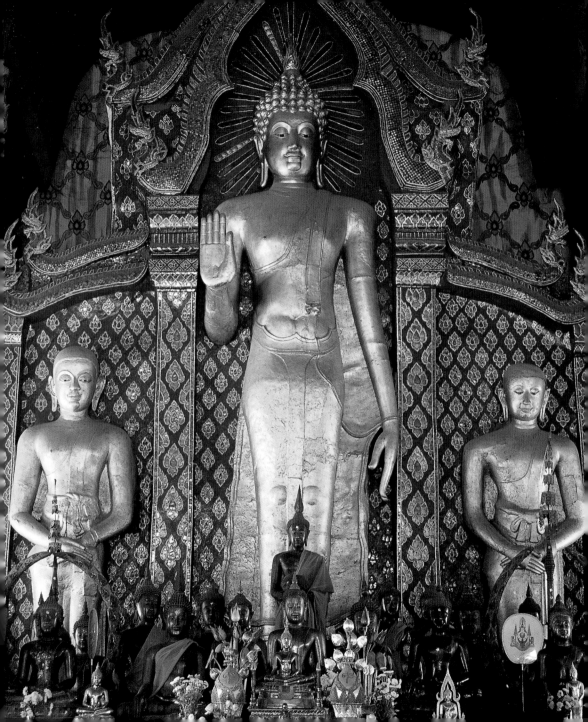

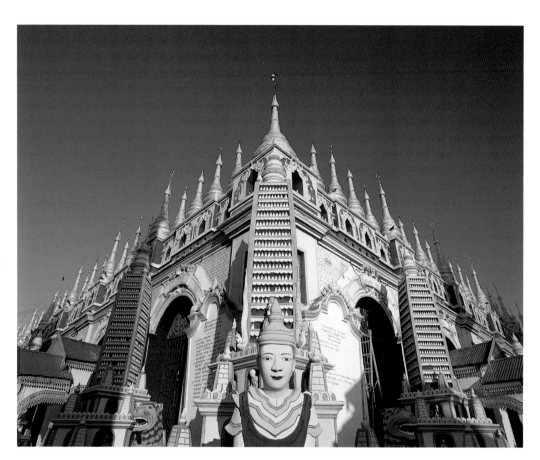

43 & 44. Thanboddhay Pagoda, Monywa, Myanmar

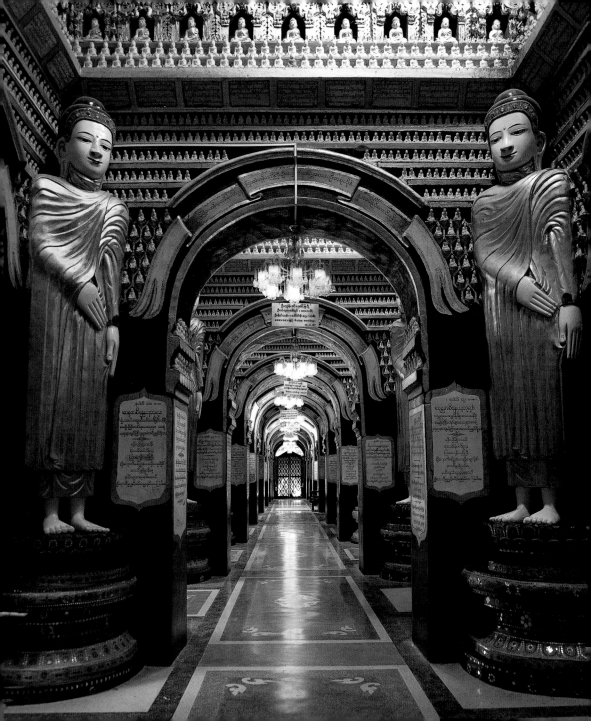

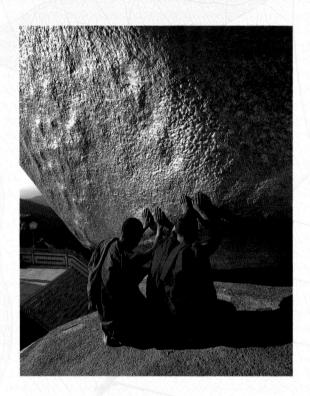

Look within.
Be still.
Free from fear and attachment,
Know the sweet joy of the way.

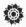

45 & 46. KYAIKTIYO PAGODA, Myanmar

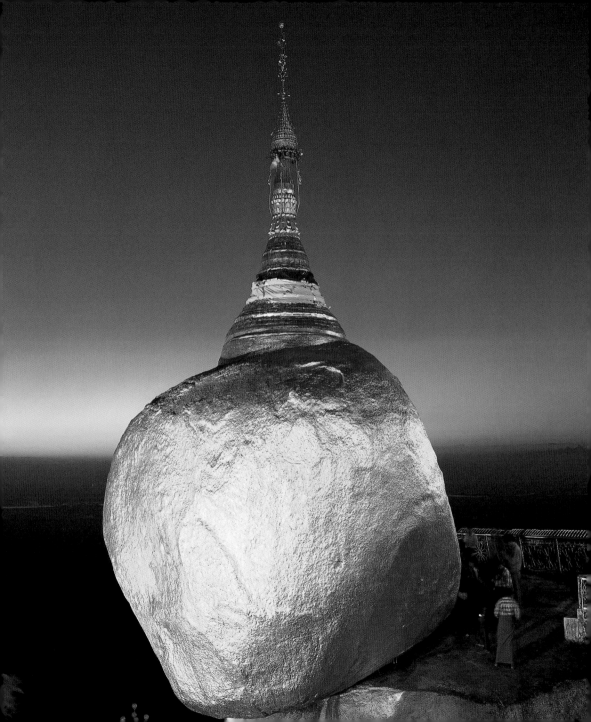

74

47. WAT SEN SOUKHARAM, Luang Prabang, Laos

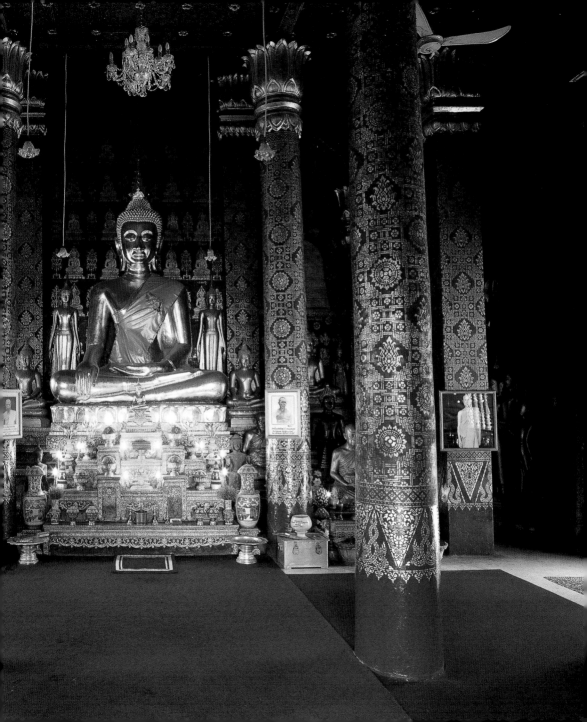

Rely on nothing
Until you want nothing.

✵

48. BOTATAUNG PAGODA, Yangon, Myanmar

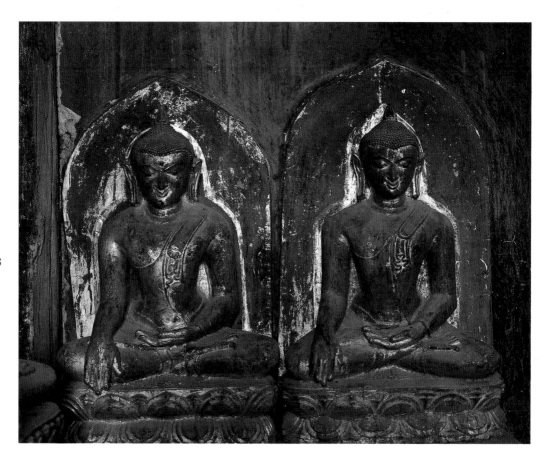

49. ANANDA PAGODA, Bagan, Myanmar
50. LUANG NUA, WAT PHRA THAT LUANG, Vientiane, Laos *(opposite)*

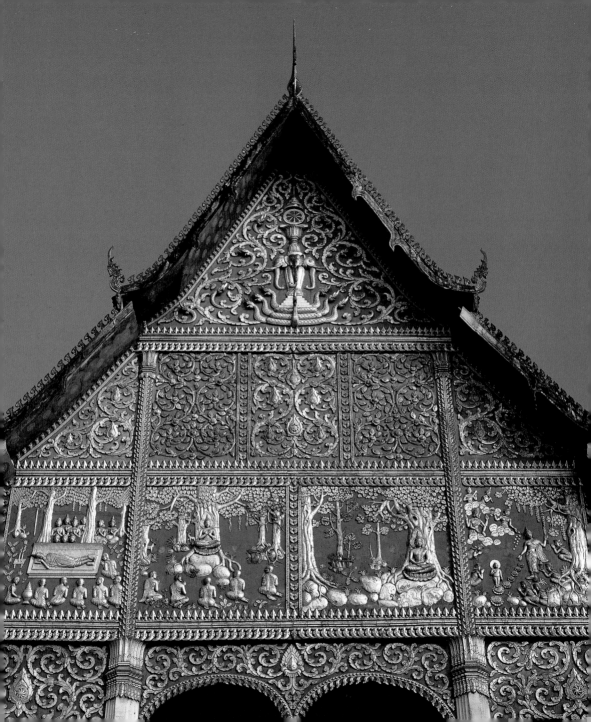

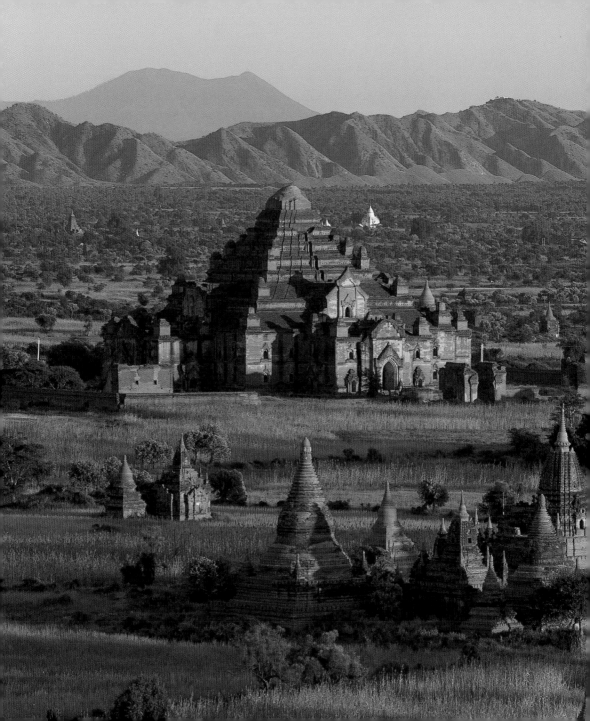

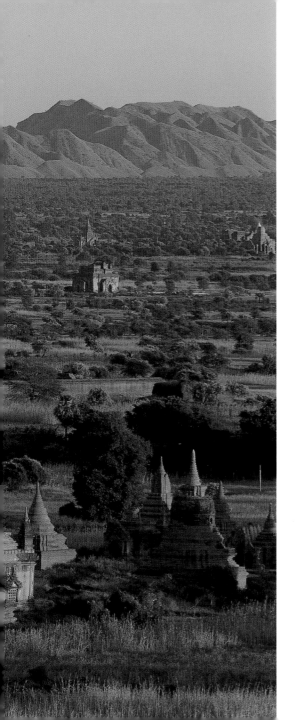

51. DHAMMAYANGYI PAGODA, Bagan,
Myanmar

When a man has crossed over a river
By the raft which he has built,
He must leave the raft
And proceed on his journey.

In this way I have taught you
The Dharma for getting across,
Not for retaining.
You must not cling to states of mind.

❁

52. PHARA OUK, Mrauk U, Myanmar

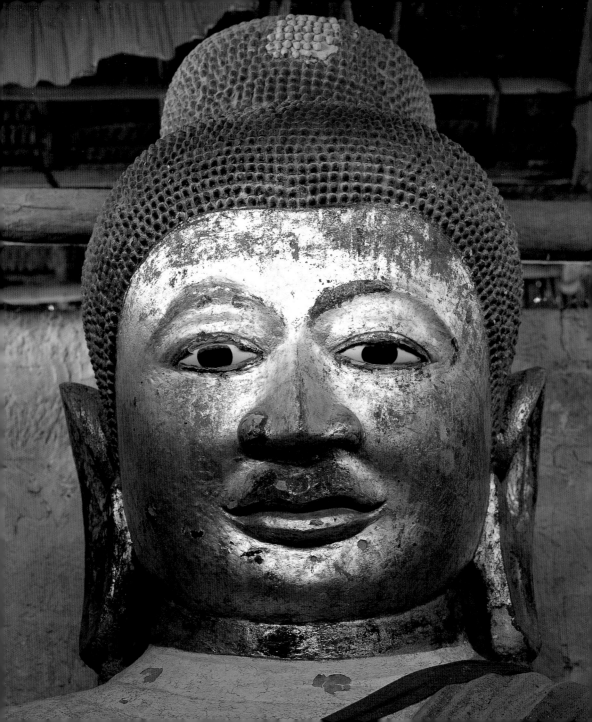

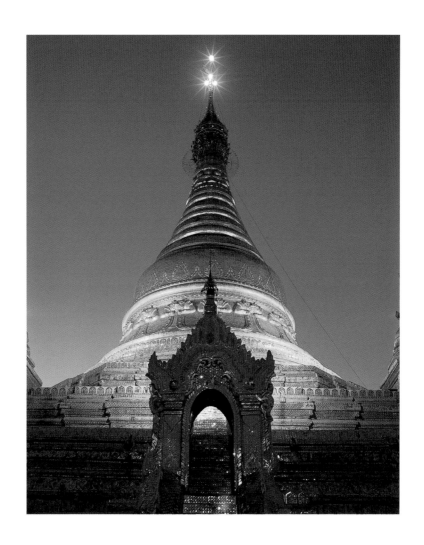

53 & 54. EINDAWYA PAGODA, Mandalay, Myanmar

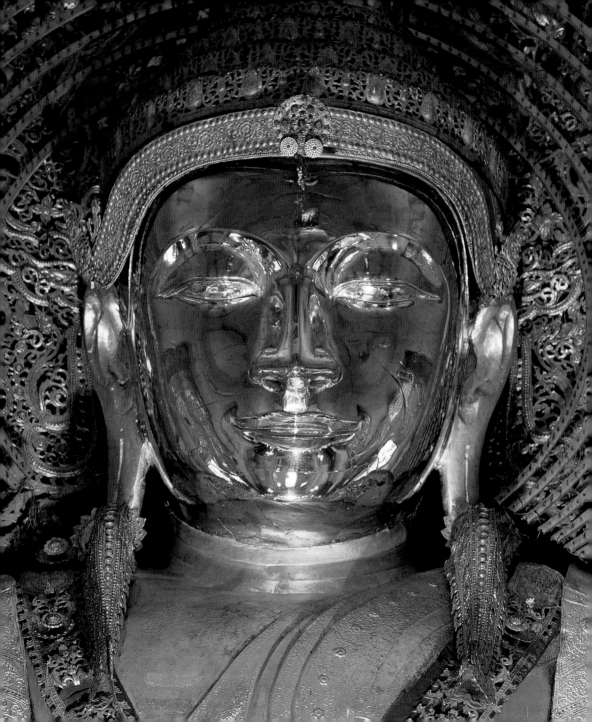

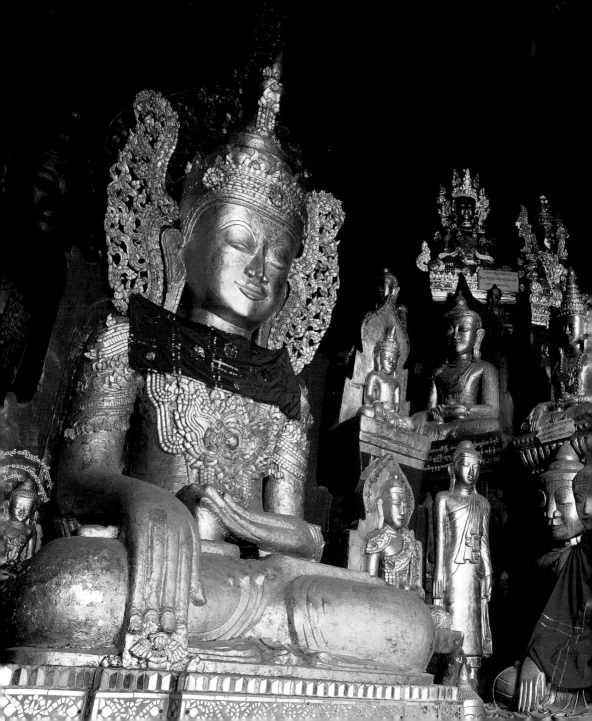

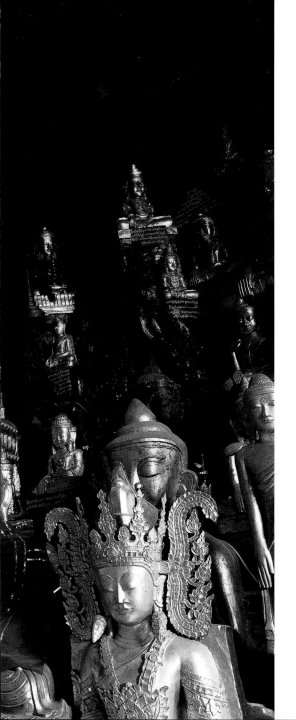

55. PINDAYA CAVES, near Pindaya, Myanmar

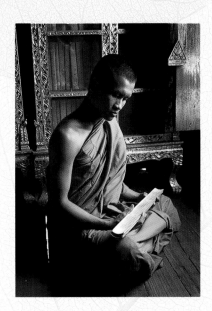

Your worst enemy cannot harm you
As much as your own thoughts, unguarded.

But once mastered,
No one can help you as much,
Not even your father or your mother.

❀

56. Palm leaf texts, WAT THUNG SI MUANG, Ubon Ratchathani, Thailand
57. SHWESIGONE PAGODA, Monywa, Myanmar *(opposite)*

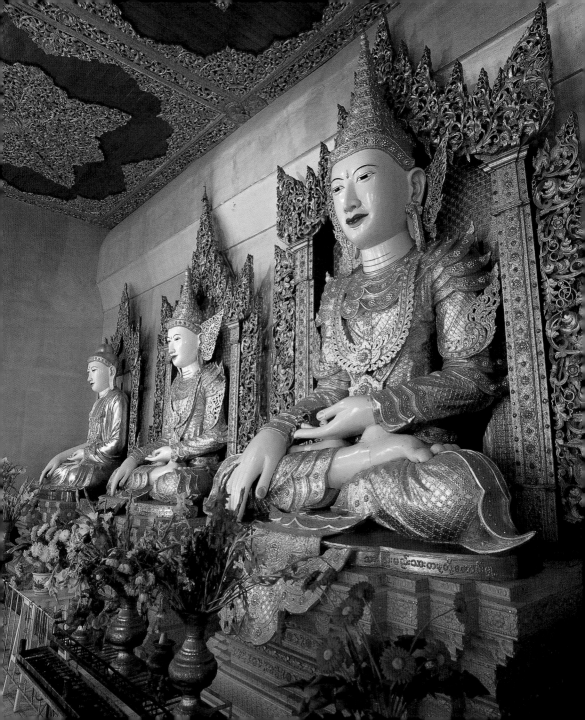

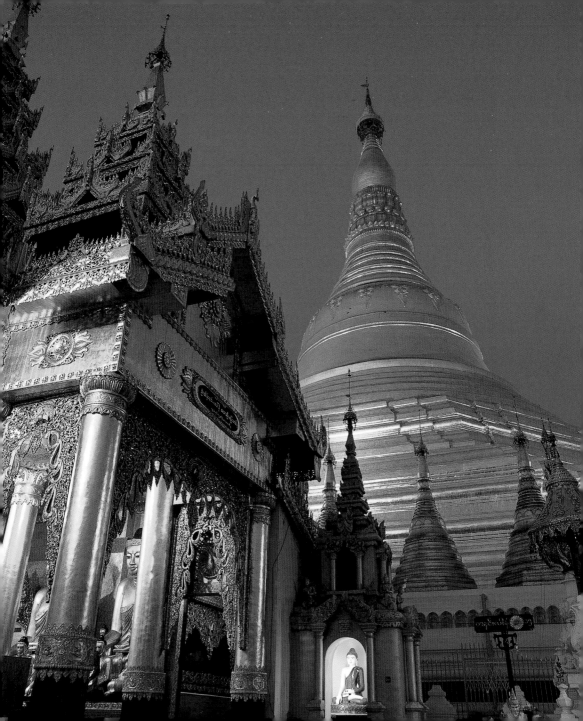

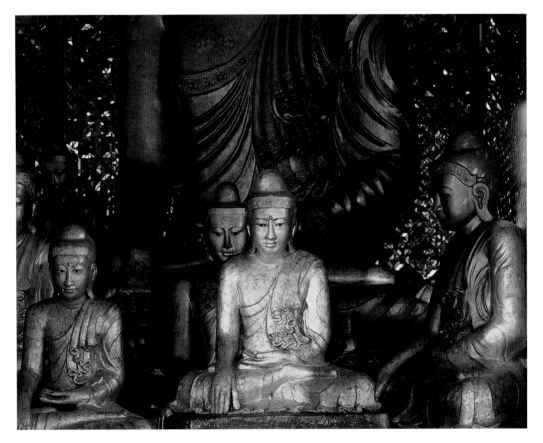

58 & 59. SHWEDAGON PAGODA, Yangon, Myanmar

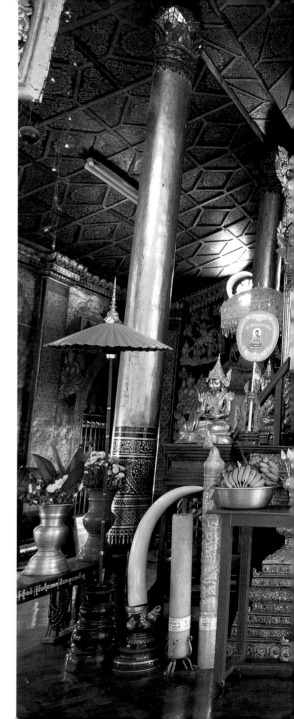

92

60. WAT JONG KHAM, Kyaing Tong, Myanmar

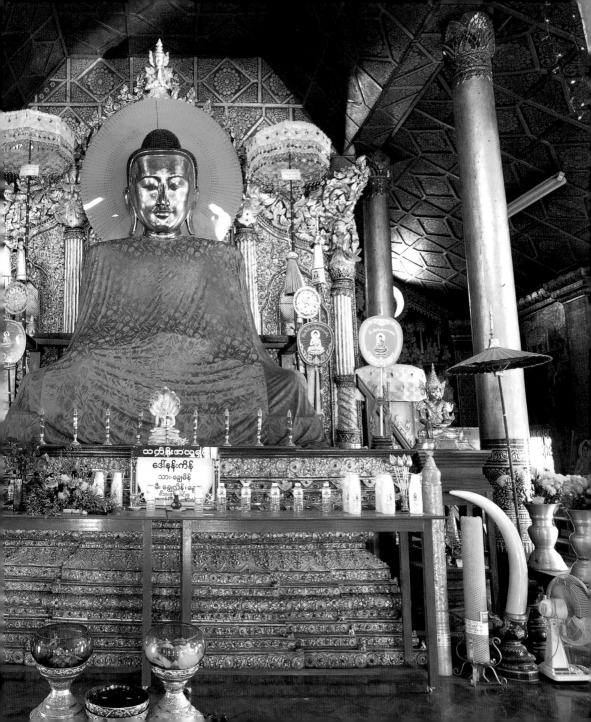

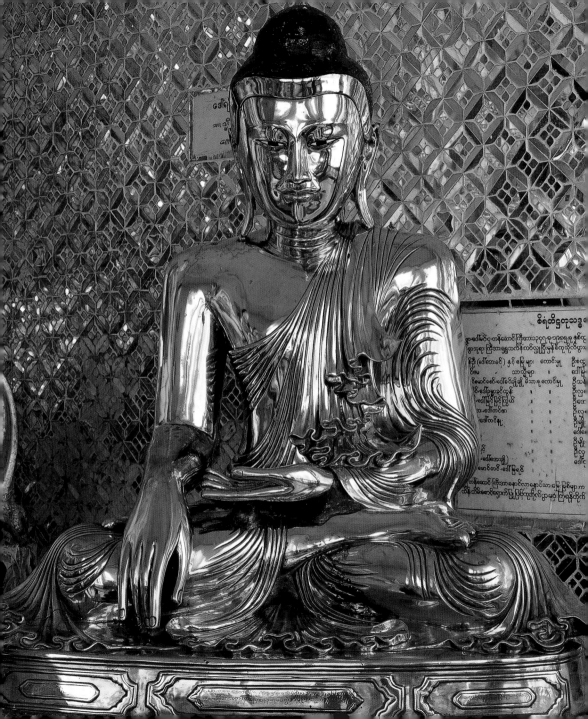

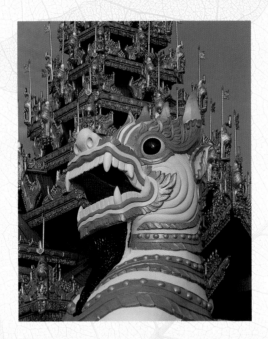

As a silversmith sifts dust from silver,
Remove your own impurities
Little by little.

Or as iron is corroded by rust
Your own mischief will consume you.

61. SHWEDAGON PAGODA, Yangon, Myanmar *(opposite)*
62. *Chinthe*, SHWEDAGON PAGODA, Yangon, Myanmar
63. SHWEDAGON PAGODA, Yangon, Myanmar *(overleaf)*

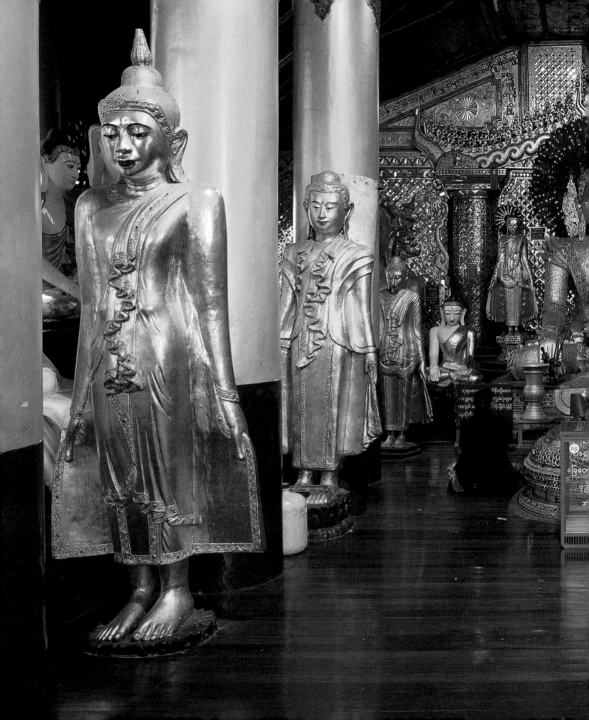

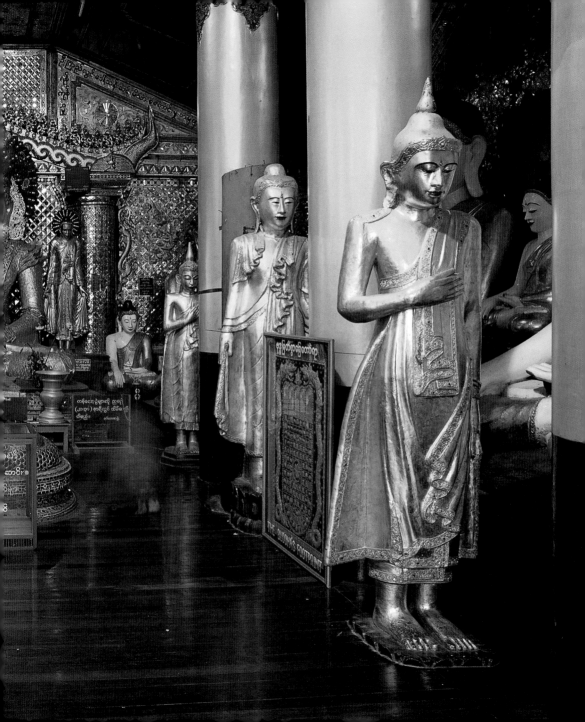

64. Soon U Ponya Shin Zedi,
Sagaing, Myanmar

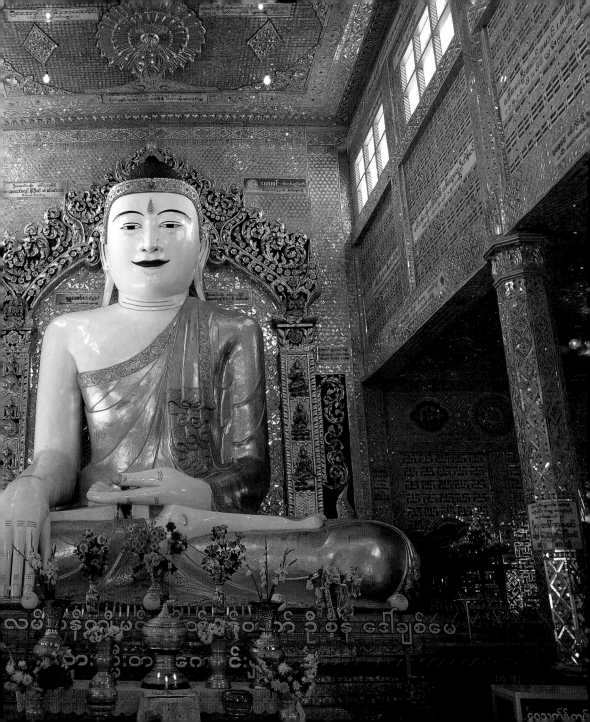

With a free mind, in no debt,
Enjoy what has been given to you.
Get rid of the tendency to judge yourself
Above, below, or equal to others.

✿

65. Detail, Mother-of-pearl doors, WAT RAJABOPIT, Bangkok, Thailand

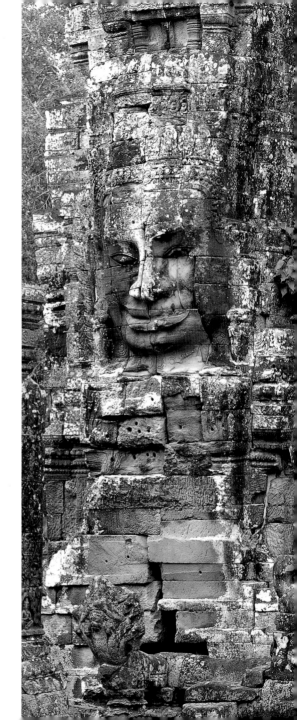

102

66. BAYON, ANGKOR THOM,
Siem Reap, Cambodia

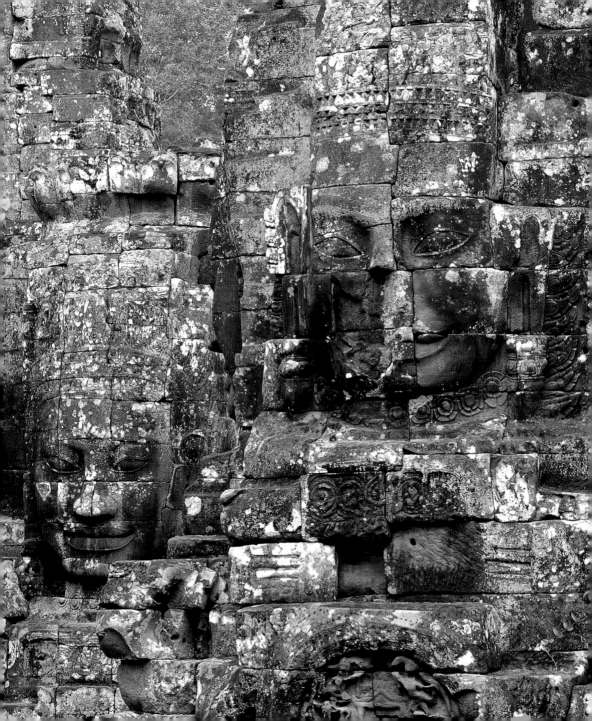

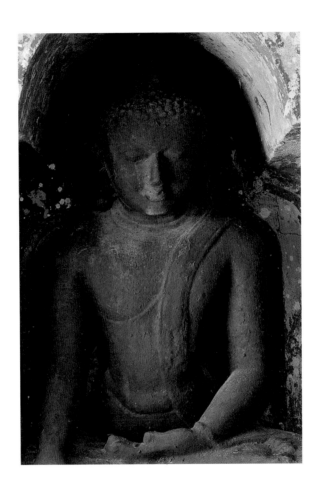

67. ANANDA PAGODA, Bagan, Myanmar
68. THAM TING, PAK OU CAVES, Mekong River, Laos *(opposite)*

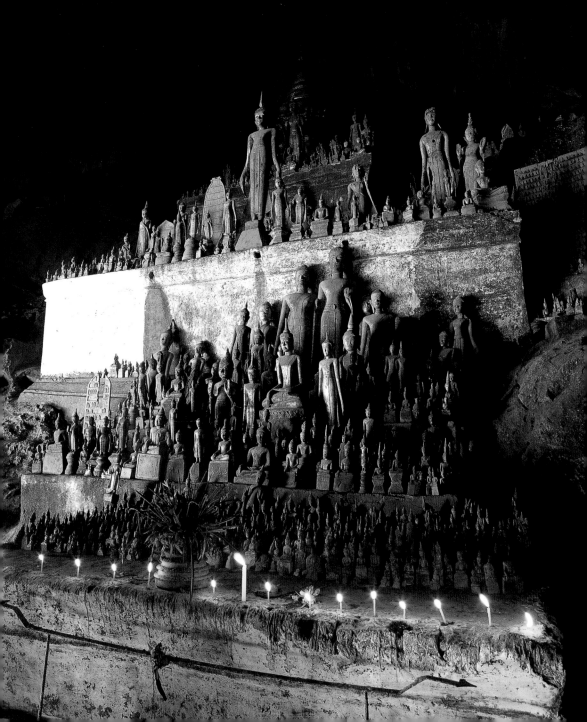

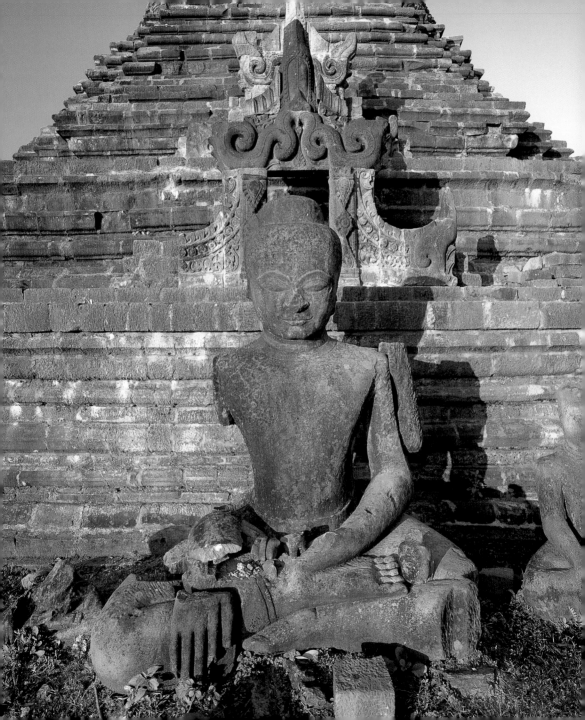

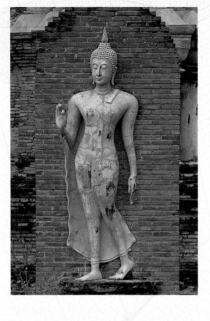

As a mother watches over her child,
Willing to risk her own life to protect her only child,
So with a boundless heart
Should one cherish all living beings,
Suffusing the whole world
With unobstructed loving–kindness.

69. MINGLA MANAUNG ZEDI, Mrauk U, Myanmar *(opposite)*
70. WAT CHETUPON, Sukhothai, Thailand

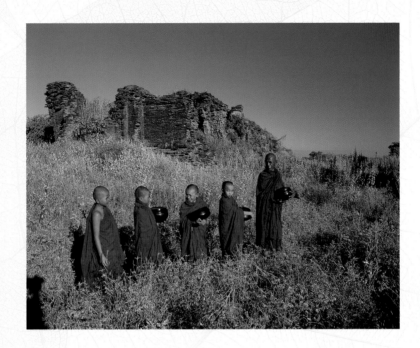

Develop the state of mind of friendliness,
For, as you do so, ill-will will grow less;
And of compassion, for thus vexation will grow less;
And of joy, for thus aversion will grow less;
And of equanimity, for thus repugnance will grow less.

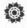

71. Monks begging for food, THAKYA BON ZEDI, Bagan, Myanmar
72. Meditating at BAWBAWGYI PAYA, Sri Ksetra, Myanmar *(opposite)*

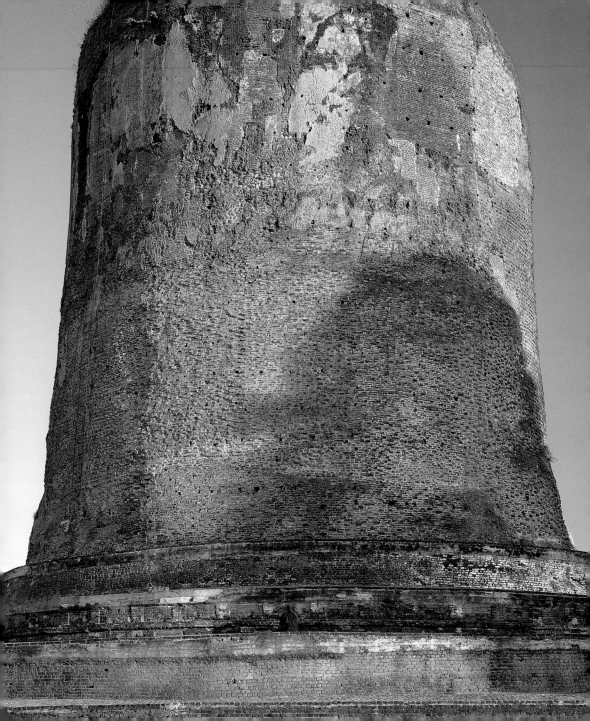

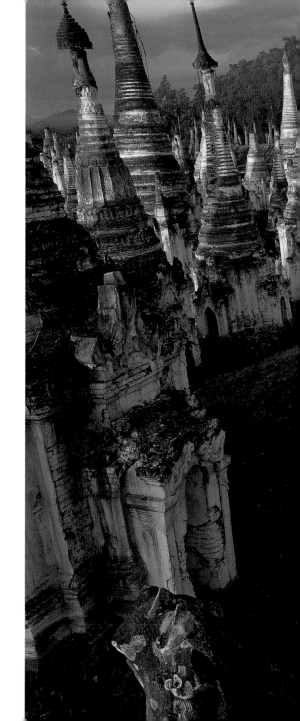

110

73. KETKU PAYA, near Taunggyi, Myanmar

With gentleness overcome anger.
With generosity overcome meanness.
With truth overcome deceit.

74. Lotus on wooden bell, WAT CHAN, Vientiane, Laos

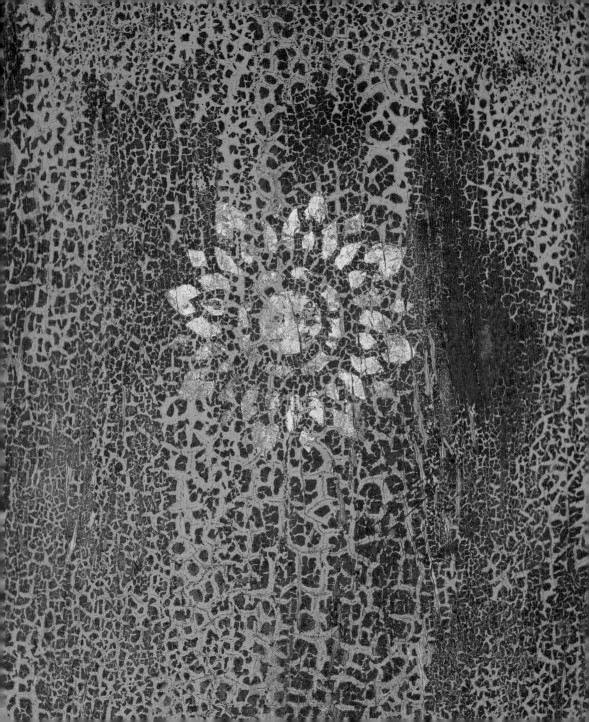

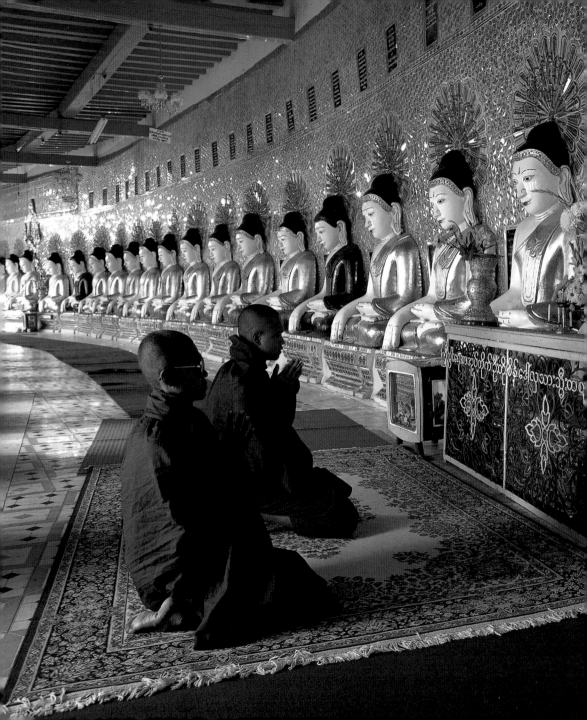

75. Ohnmin Thonza Paya, Sagaing, Myanmar

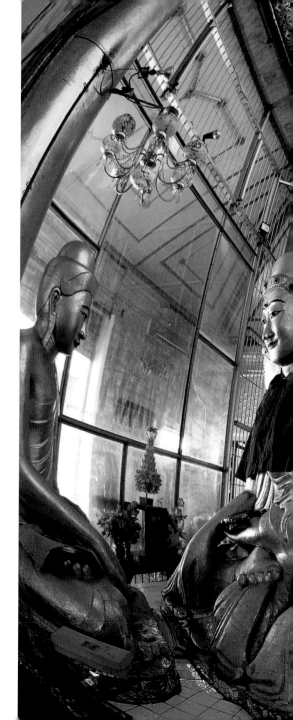

76. *Kyaikhami,* YAYLEH PAGODA,
Kyaikhami, Myanmar

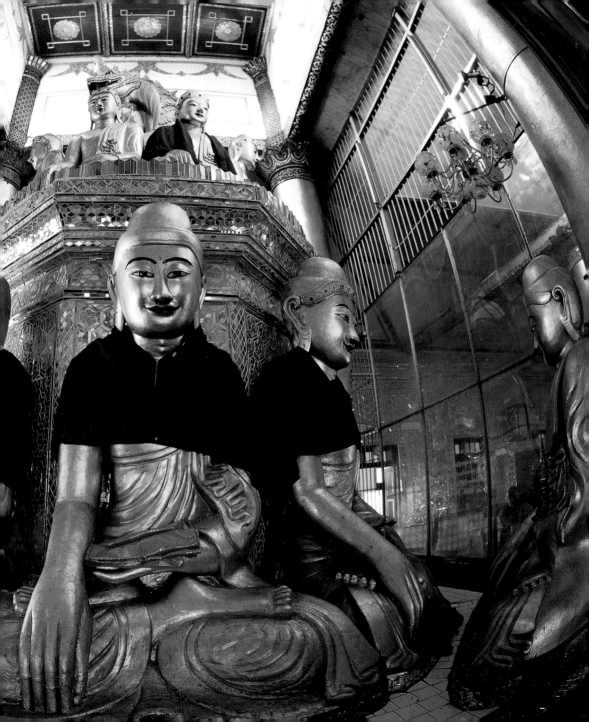

All beings tremble before violence.
All fear death.
All love life.

See yourself in others.
Then whom can you hurt?
What harm can you do?

❋

77. *Maha Muni*, Mandalay, Myanmar

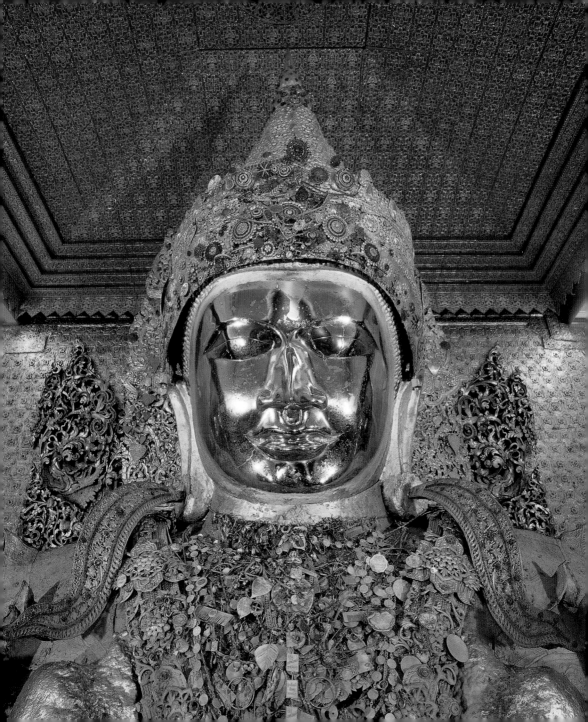

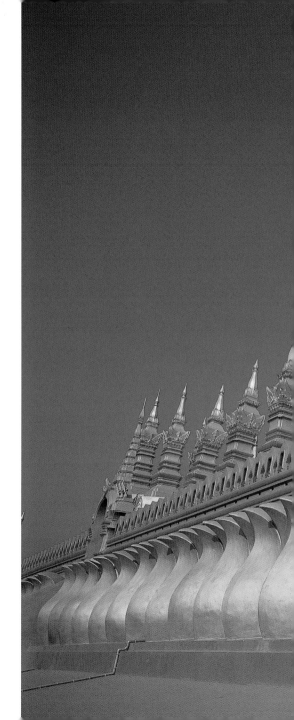

120

78. WAT PHRA THAT LUANG,
Vientiane, Laos

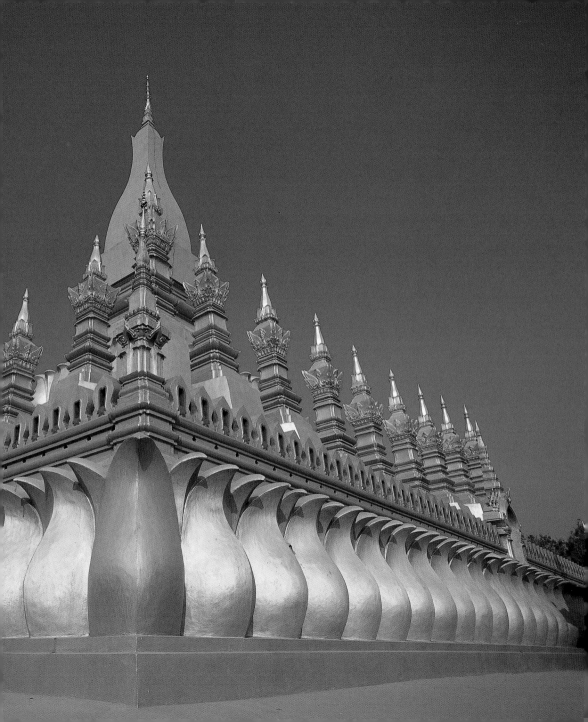

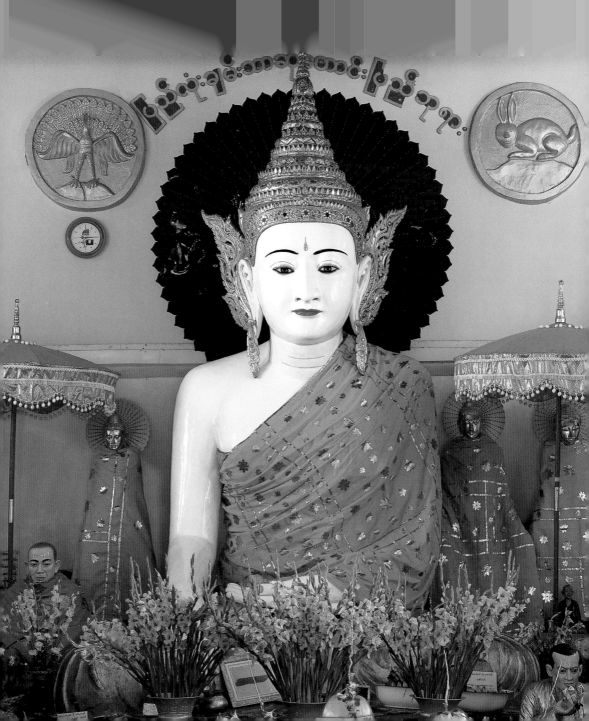

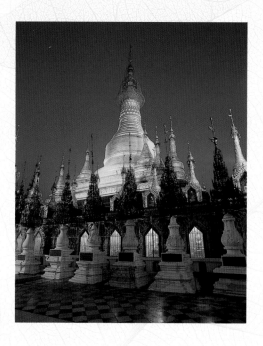

What one has heard there,
One does not repeat here,
So as to cause dissension here.
Thus one unites those that are divided;
And those that are united, one encourages.

79. SHWEDAGON PAGODA, Yangon, Myanmar *(opposite)*
80. SHWESANDAW PAGODA, Pyay, Myanmar

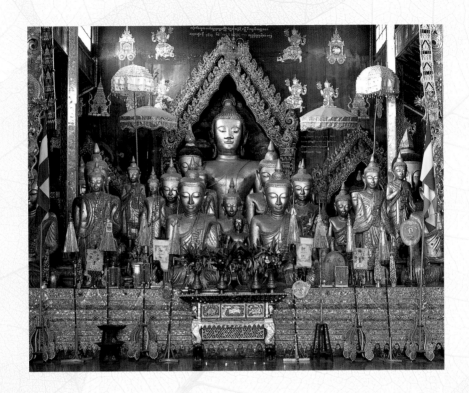

124

If you will not take care of each other,
Who else will do so?
Those who would attend to me,
Let them attend to the sick.

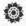

81. WAT RAJATARM LOANG, Kyaing Tong, Myanmar
82. Buddhist scriptures, KUTHADAW PAGODA, Mandalay, Myanmar *(opposite)*

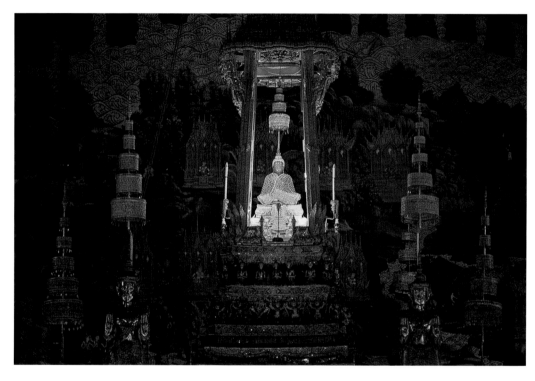

83. *The Emerald Buddha*, WAT PHRA KAEO, GRAND PALACE, Bangkok, Thailand
84. WAT BENJAMABOPIT, Bangkok, Thailand *(opposite)*

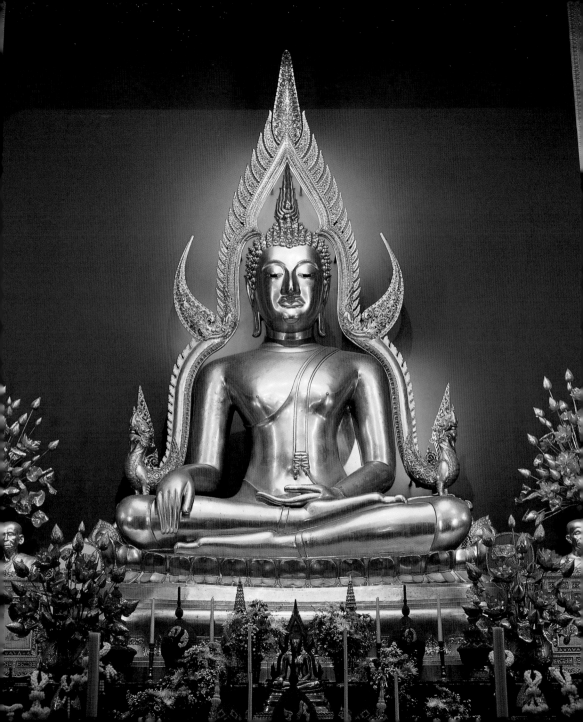

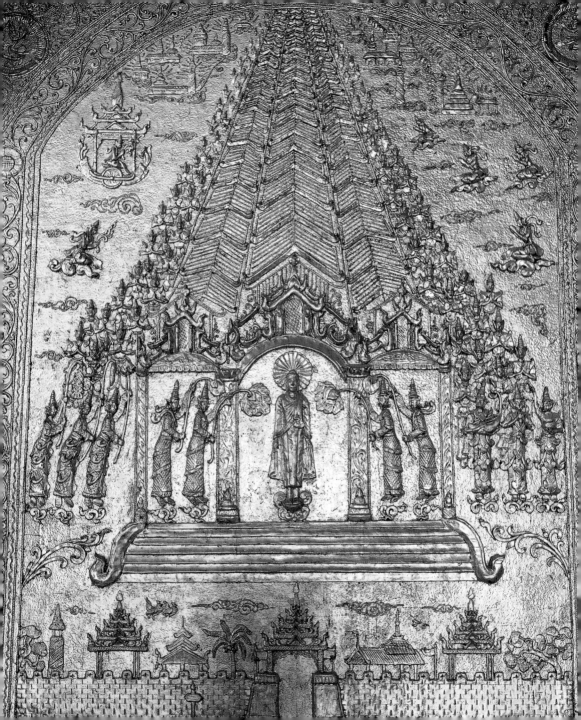

H arsh words do not serve as a remedy
And are pleasant to no one.

85. KYAIKBAWLAW PAGODA, Kyaikto, Myanmar *(opposite)*
86. WAT PHAN TAO, Chiang Mai, Thailand

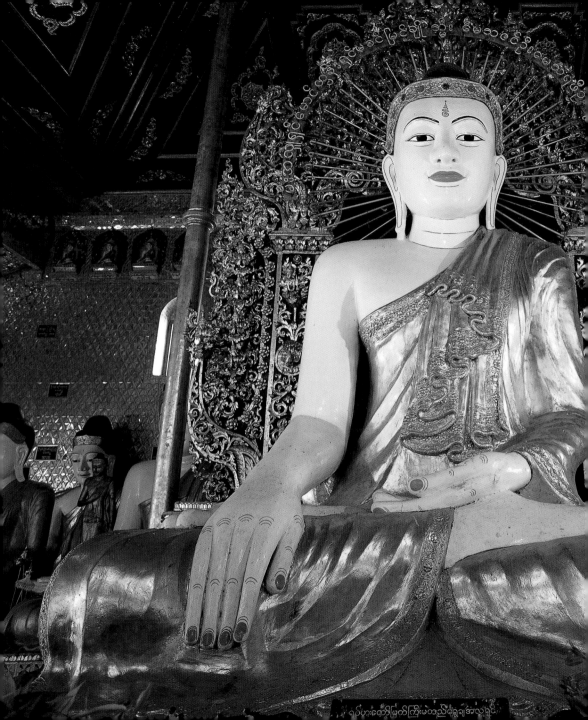

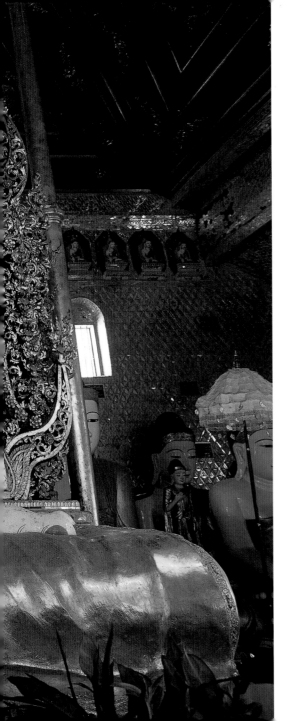

87. SHWESAYAN PAGODA, Thaton, Myanmar

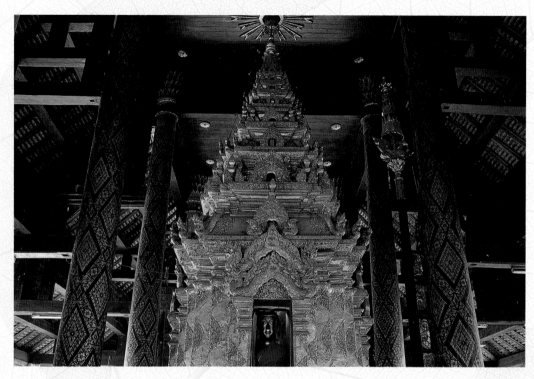

132

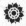

The greatest gain is to give to others;
The greatest loss is to receive without gratitude.

88. *Phra Chao Lang Thong*, WAT PHRA THAT, Lampang Luang, Thailand
89. *Sehhtatgyi*, Pyay, Myanmar *(opposite)*
90. Detail, Ceramic decoration, WAT RAJABOPIT, Bangkok, Thailand *(overleaf)*

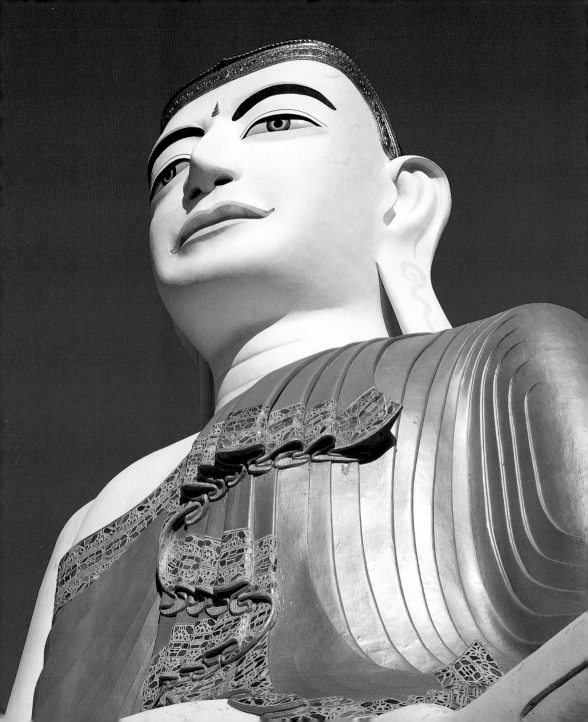

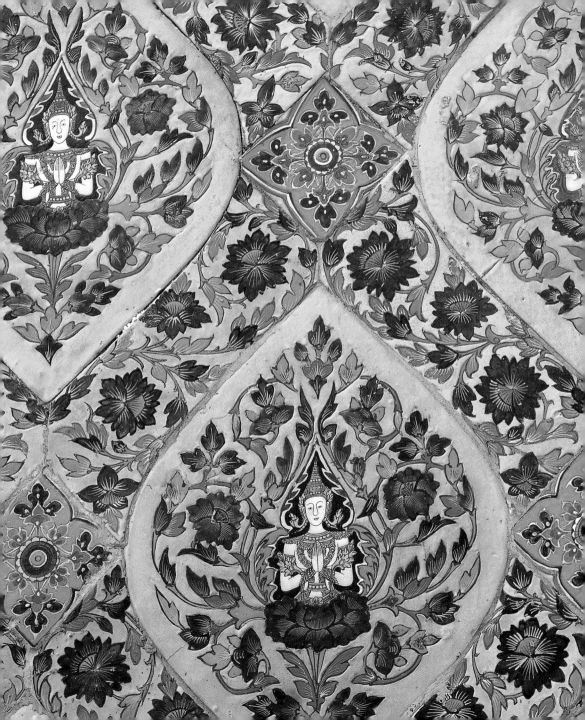

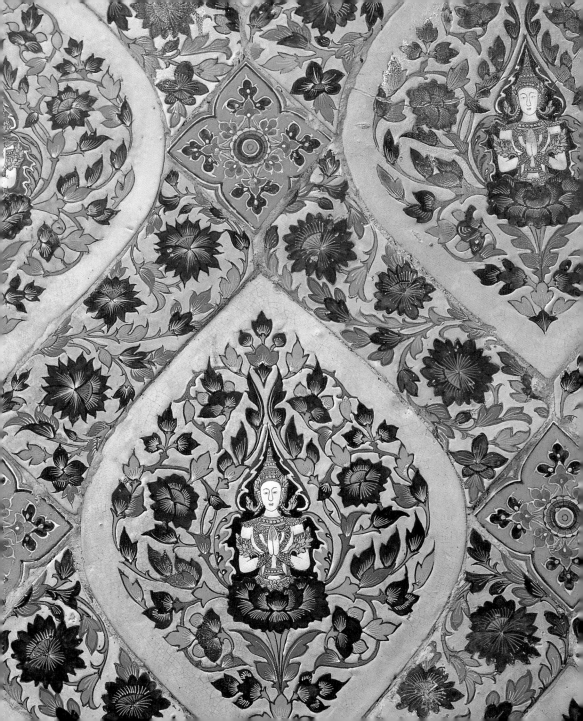

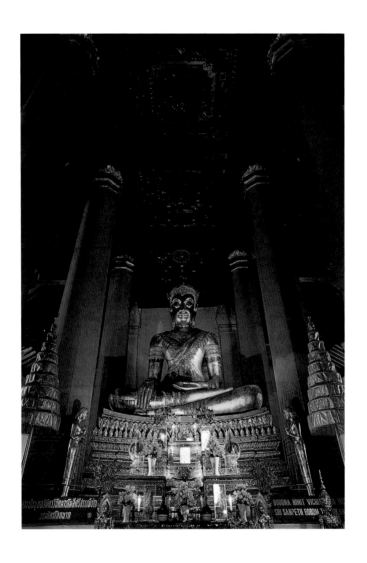

91. WAT NA PRAMAN, Ayutthaya, Thailand
92. WAT PHRA MAHA THAT, Luang Prabang, Laos *(opposite)*

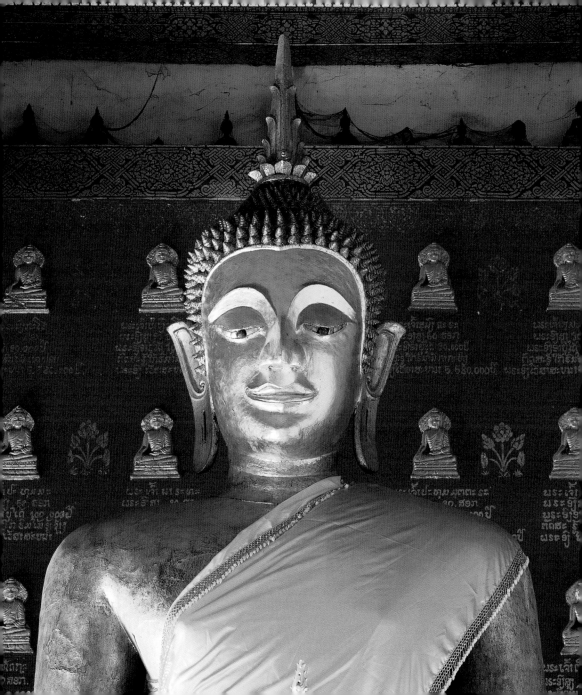

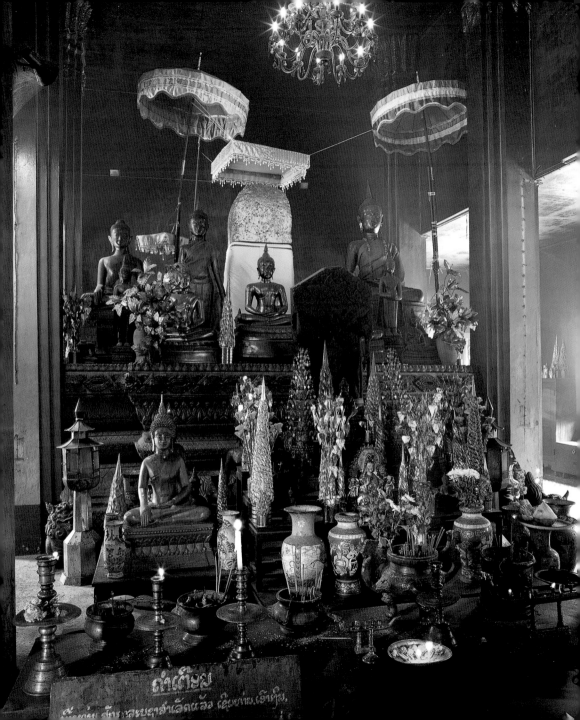

ถ้ำเตียบ

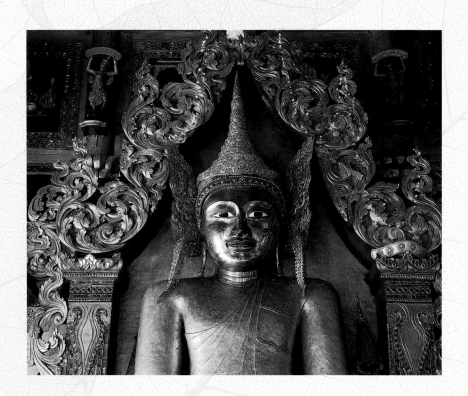

Look to your own faults,
What you have done or left undone.
Overlook the faults of others.

93. WAT SI MUANG, Vientiane, Laos *(opposite)*
94. MAHA MUNI PAGODA, Dhanyawaddy, Myanmar

140

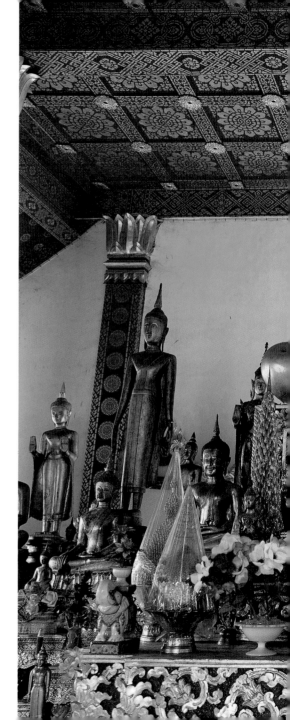

95. WAT NONG SIKHUN MUANG,
Luang Prabang, Laos

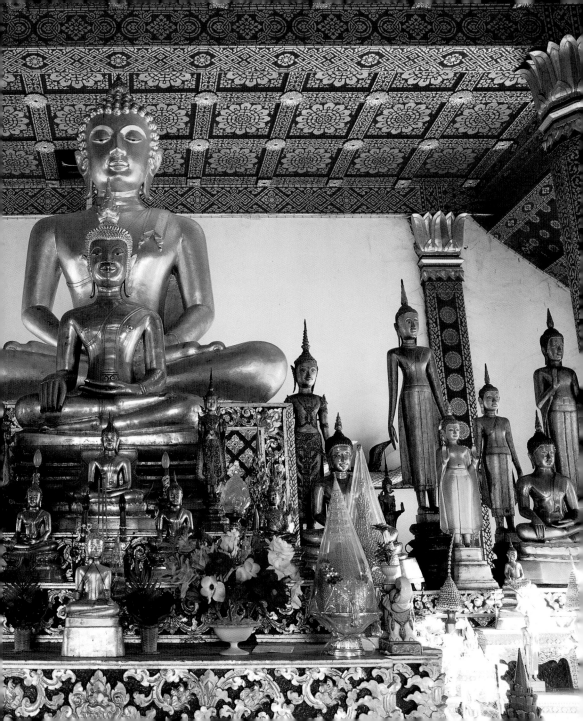

In this world
Hate never yet dispelled hate.
Only love dispels hate.
This is the law,
Ancient and inexhaustible.

You too shall pass away.
Knowing this, how can you quarrel?

96. PHRA SRI RATANA CHEDI, GRAND PALACE, Bangkok, Thailand
97. *Bodhi* tree, SHWEDAGON PAGODA, Yangon, Myanmar *(opposite)*

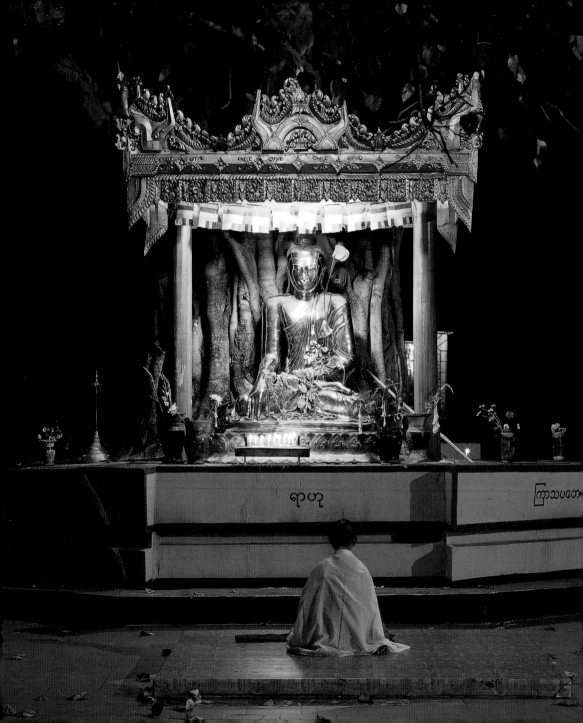

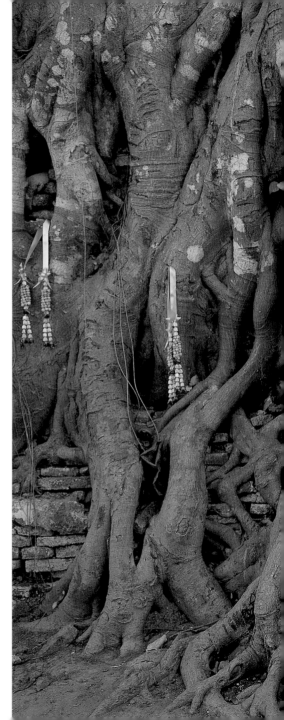

144

98. WAT MAHA THAT, Ayutthaya, Thailand

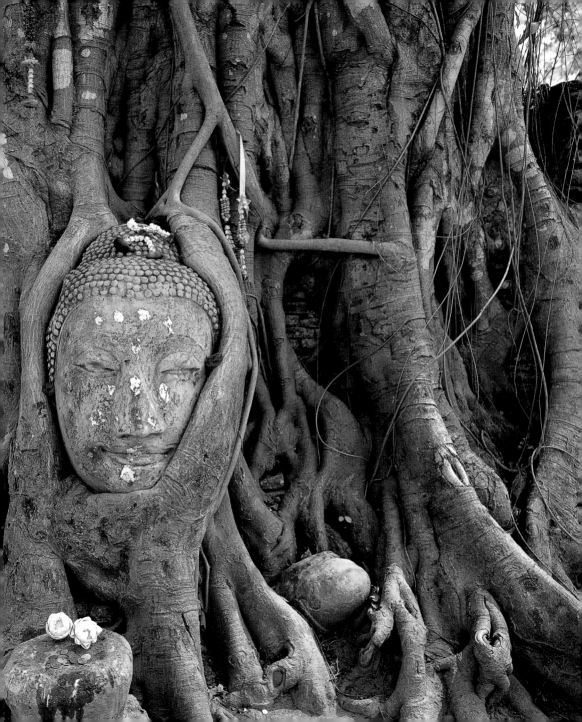

99. Bodhithataung Pagoda,
near Monywa, Myanmar

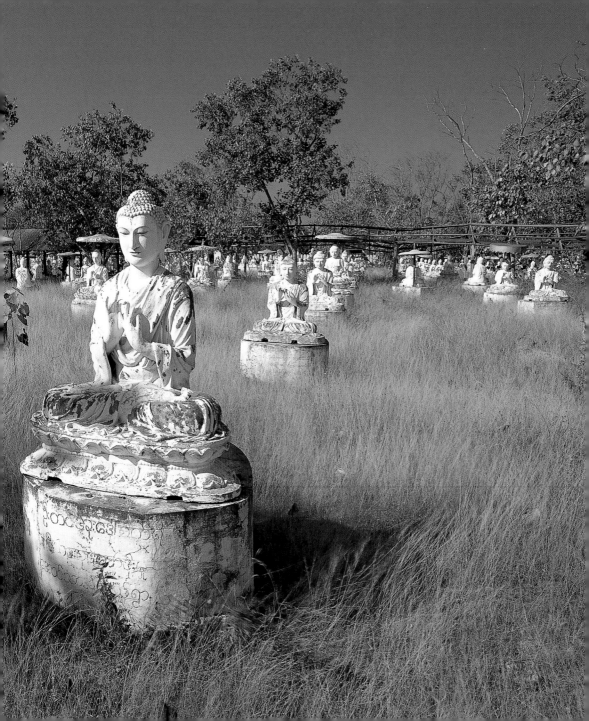

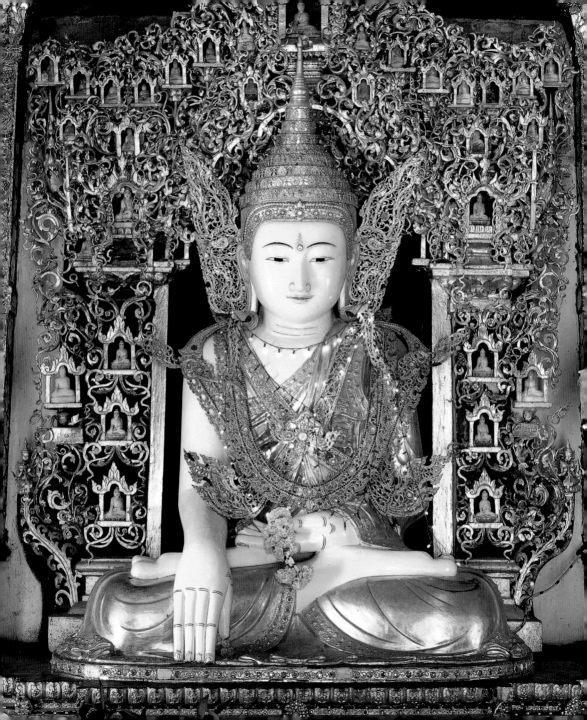

One goes to the forest,

To the foot of a tree,

Or to an empty room,

Sits down cross-legged

In the lotus position,

Holds one's body straight,

And establishes mindfulness in front of oneself.

100. U MIN KOSEN, Sagaing, Myanmar *(opposite)*
101. *Nagas*, WAT BOWONIVET, Bangkok, Thailand

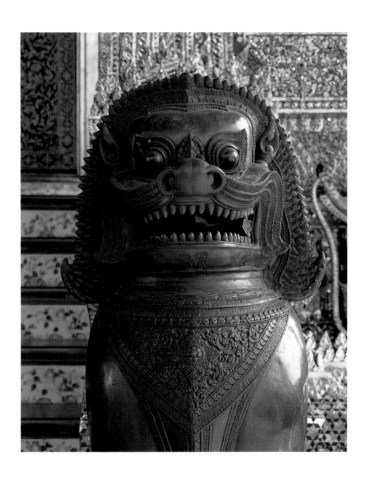

102. *Singha*, WAT PHRA KAEO, GRAND PALACE, Bangkok, Thailand
103. *Chedi*, GRAND PALACE, Bangkok, Thailand *(opposite)*

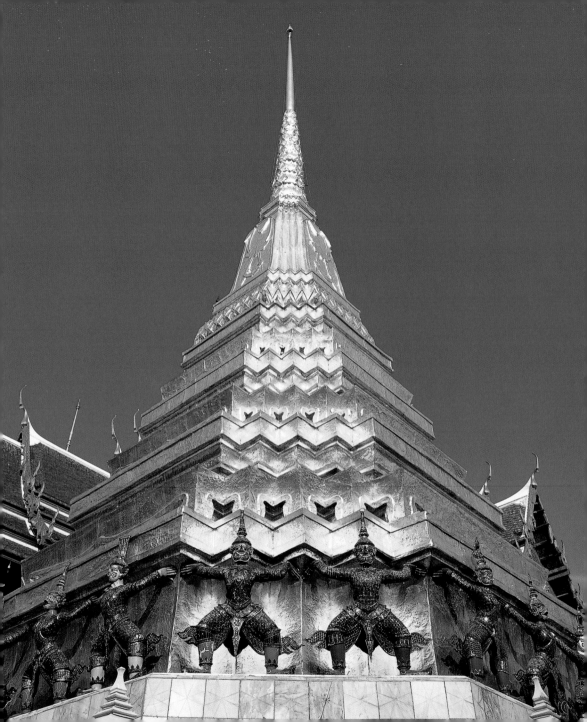

Meditate.
Live purely.
Be quiet.
Do your work, with mastery.

104. *The Attack of Mara*, TEP PRANAM, Siem Reap, Cambodia

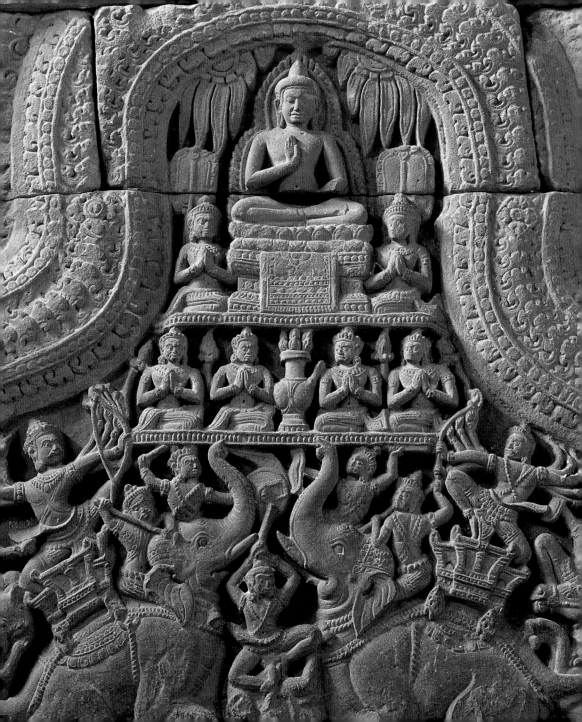

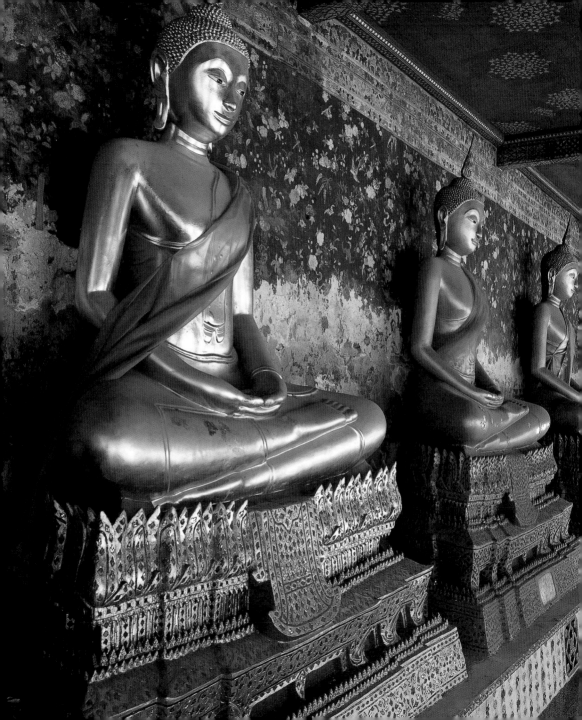

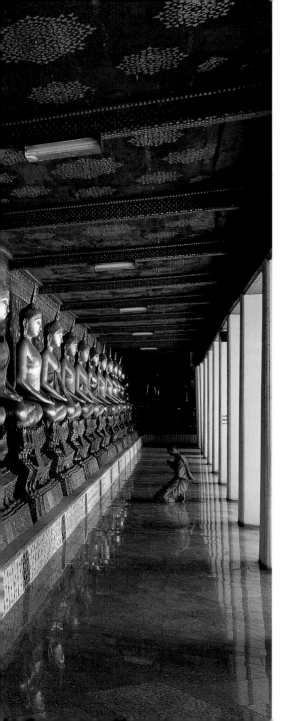

105. WAT SUTHAT, Bangkok, Thailand

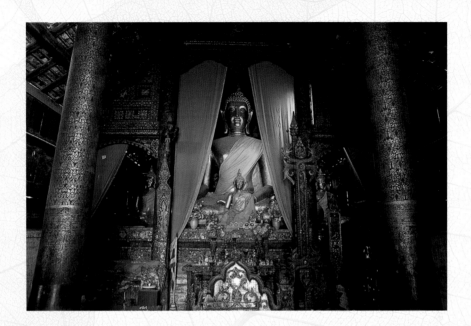

If energy is applied too strongly,
It will lead to restlessness,
And if energy is too lax
It will lead to lassitude.
Therefore, keep your energy in balance
And in this way focus your attention.

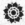

106. WIHAN PHRA PHUT, WAT PHRATHAT LAMPANG LUANG, Lampang Luang, Thailand
107. WIHAN NAM TAM, WAT PHRATHAT LAMPANG LUANG, Lampang Luang, Thailand *(opposite)*

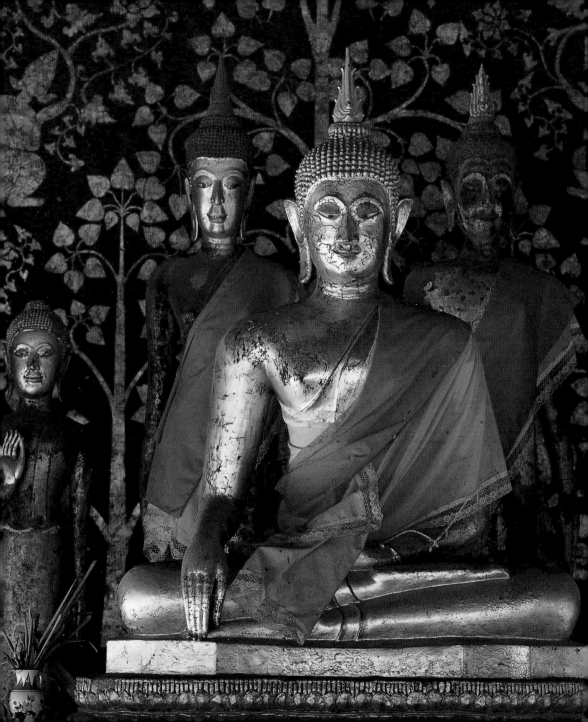

We are what we think.
All that we are arises with our thoughts.
With our thoughts we make the world.

❁

108. *Sanar Muni*, KALAMYO PAGODA, Mrauk U, Myanmar

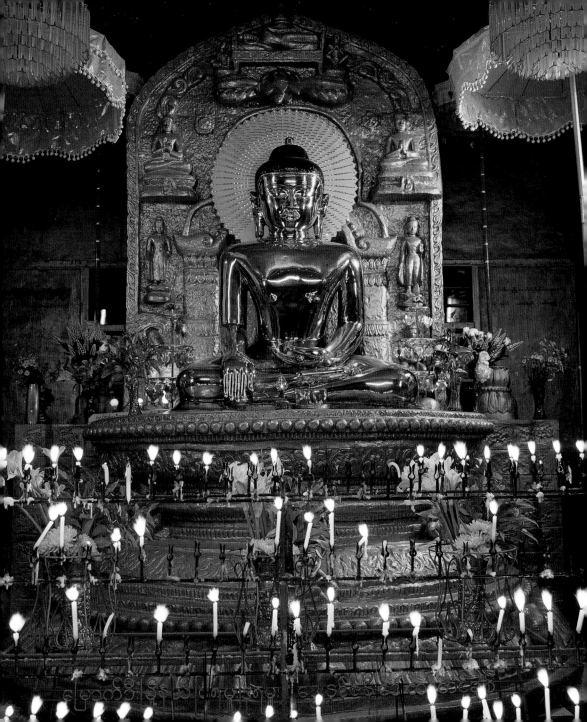

109. ATULA MARAZEIN PYILON CHANTHA
(PAYA GYI), Sitwe, Myanmar

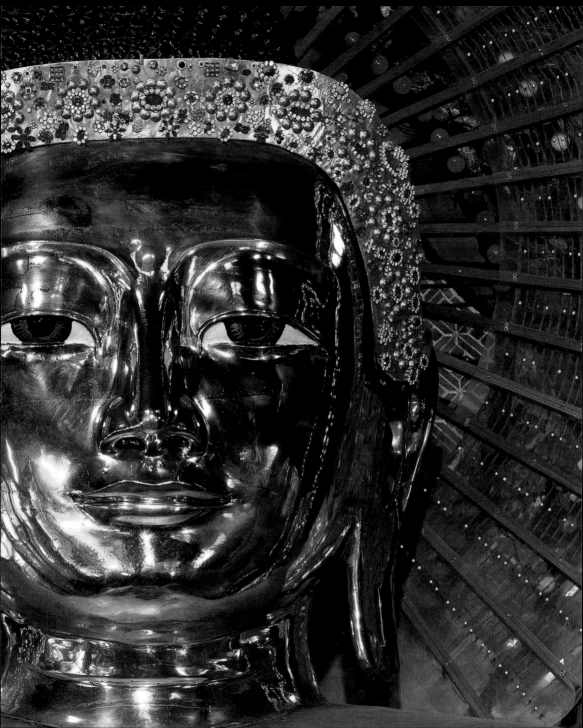

Do not pursue the past.

Do not lose yourself in the future.

The past no longer is.

The future has not yet come.

Looking deeply at life as it is

In the very here and now,

The practitioner dwells

In stability and freedom.

We must be diligent today.

To wait until tomorrow is too late.

Death comes unexpectedly.

How can we bargain with it?

✦

110. Yadana Labamuni Pagoda, near Mandalay, Myanmar

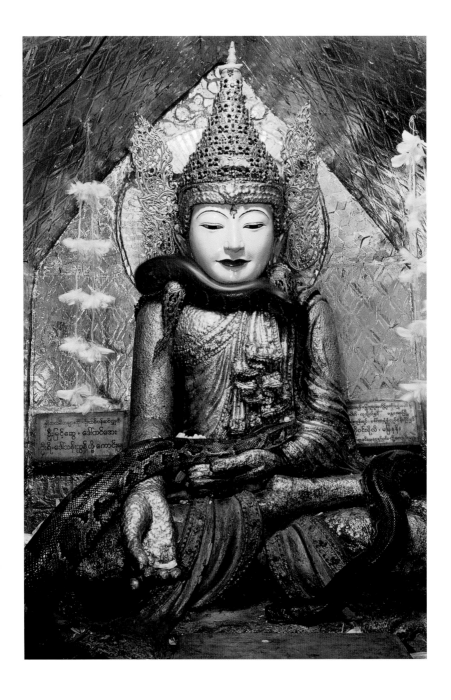

164

111. KYAIKBAWLAW PAGODA, Kyaikto, Myanmar

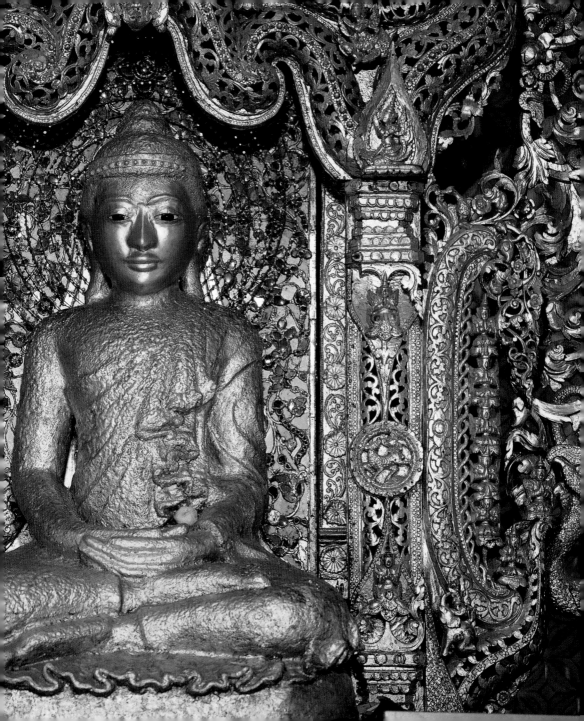

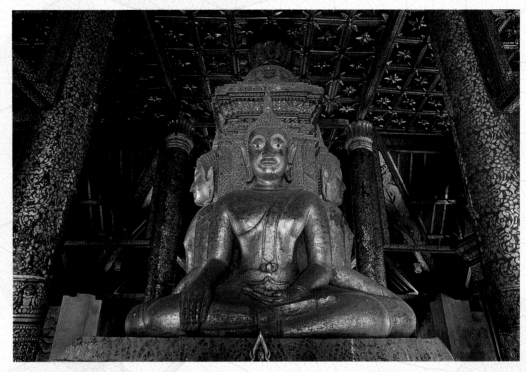

Do only what you do not regret.

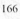

112. WAT PHUMIN, Nan, Thailand

113. *Maha Muni*, Mawlamyine, Myanmar *(opposite)*

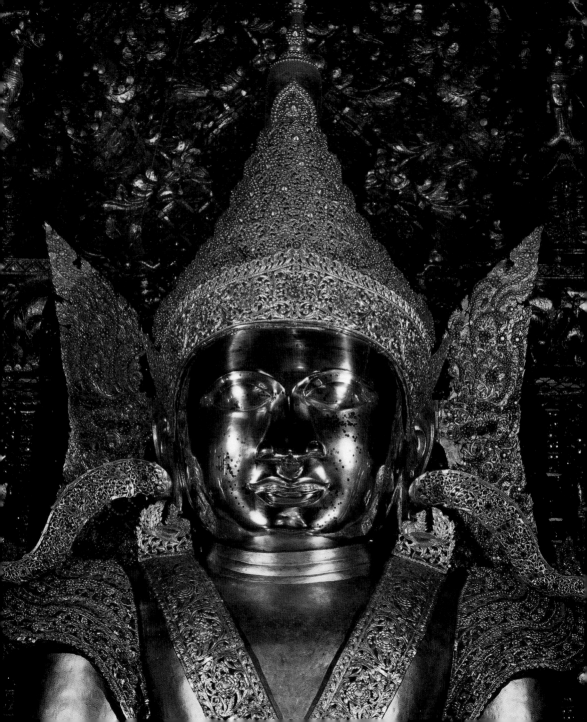

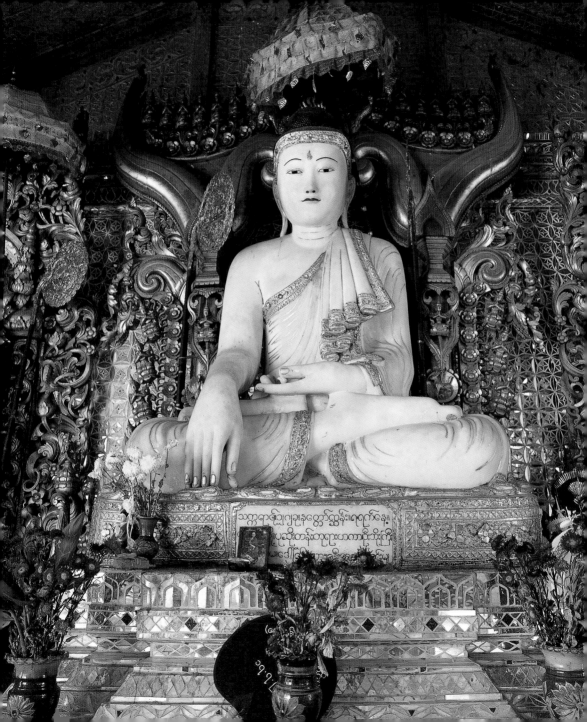

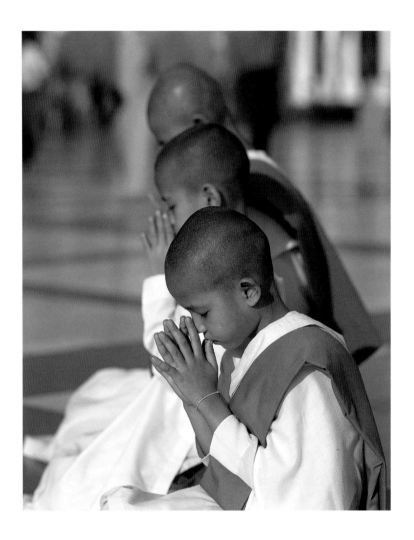

169

114 & 115. Sʜᴡᴇᴅᴀɢᴏɴ Pᴀɢᴏᴅᴀ, Yangon, Myanmar

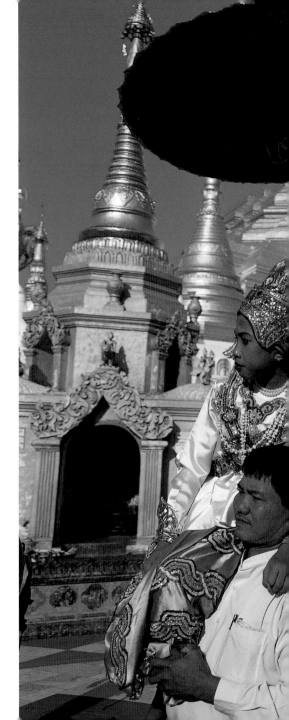

116. *Shin Pyu* ceremony, SHWEDAGON PAGODA,
Yangon, Myanmar

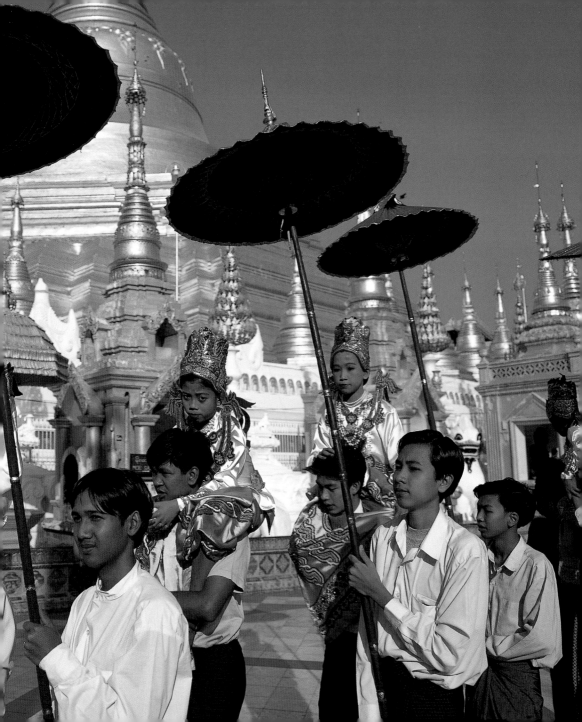

Never neglect your work
For another's,
However great his need.

Your work is to discover your work
And then with all your heart
To give yourself to it.

117. WAT MANOROM, Luang Prabang, Laos
118. SHWEKYIMYINT PAGODA, Mandalay, Myanmar *(overleaf)*

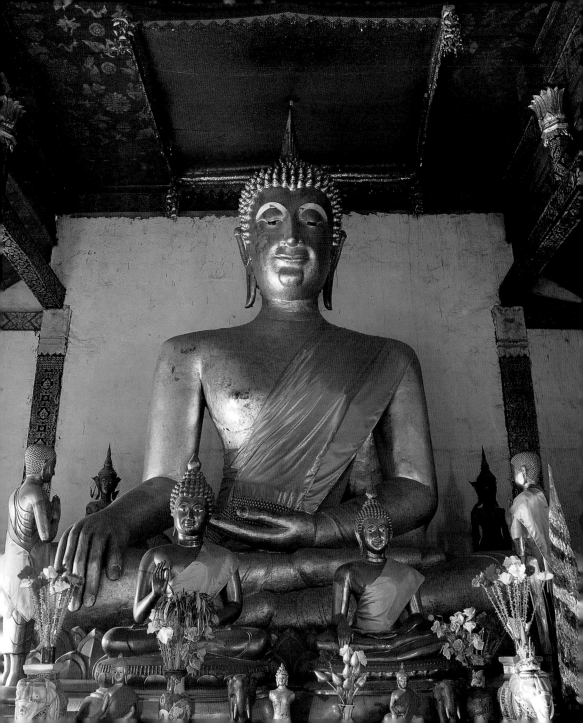

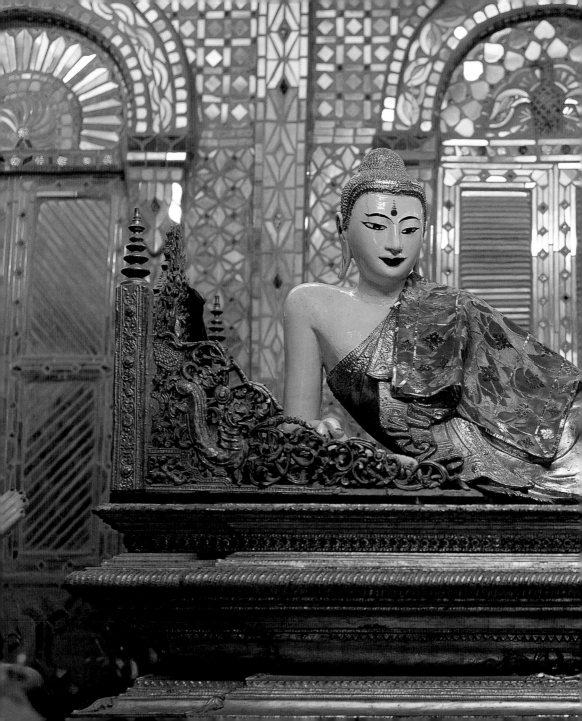

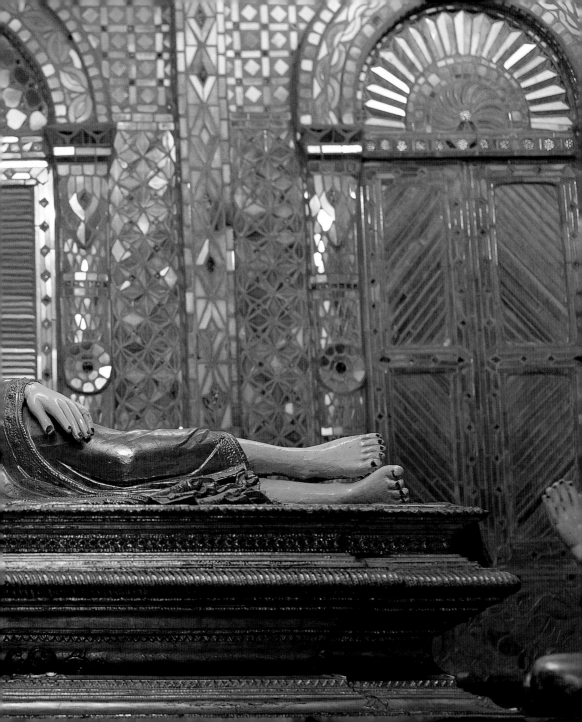

It is you who must make the effort.
The masters only point the way.

❀

119. SHWEDAGON PAGODA, Yangon, Myanmar

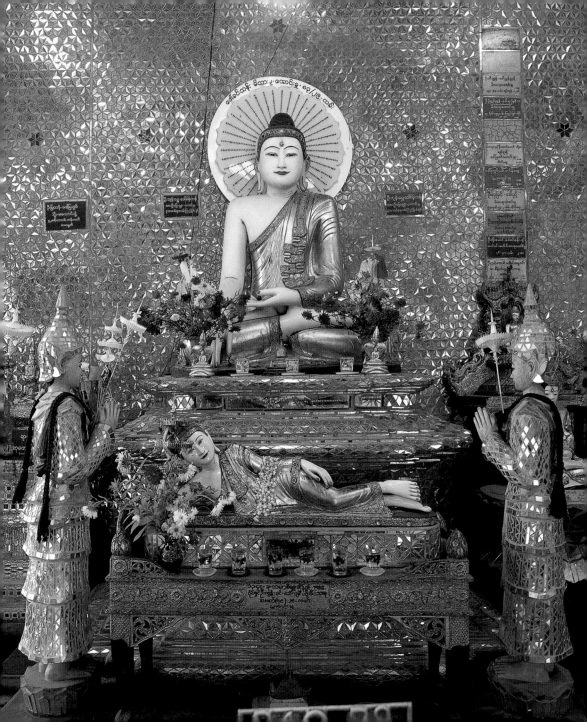

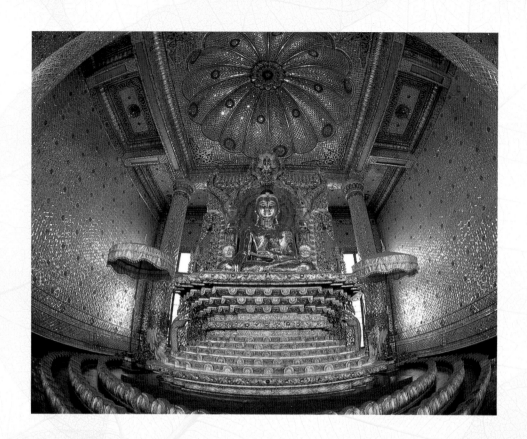

Do not look for bad company
Or live with those who do not care.
Find friends who love the truth.

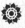

120 & 121. BOTATAUNG PAGODA, Yangon, Myanmar

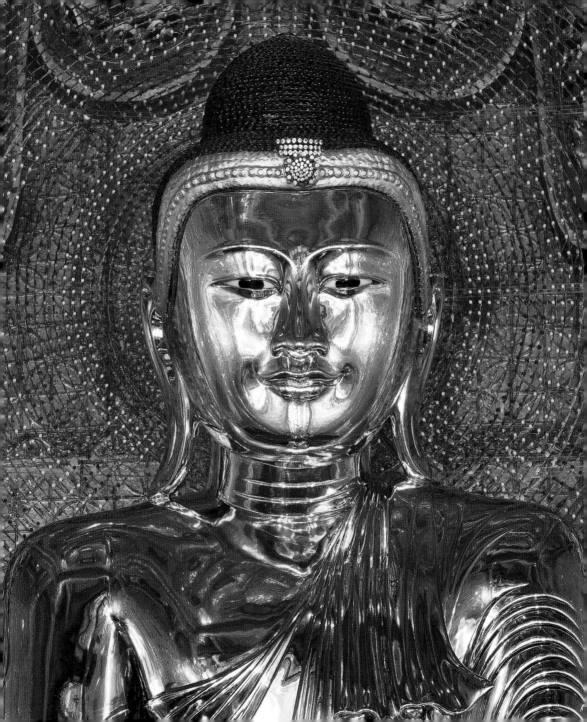

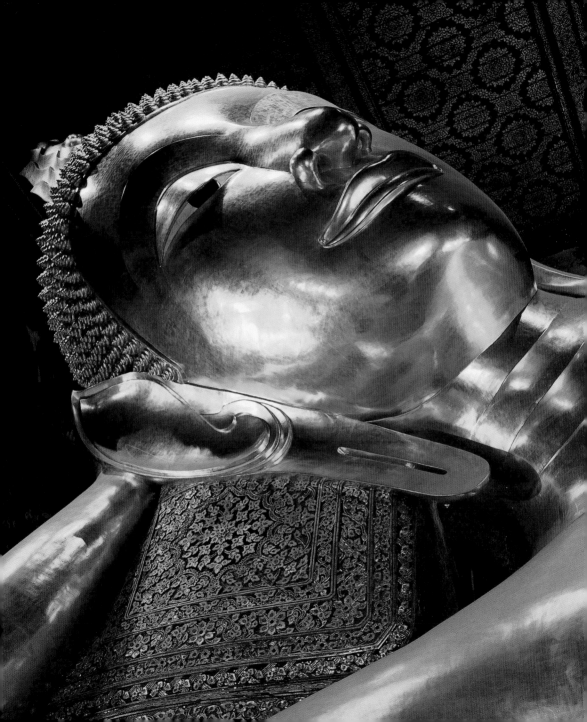

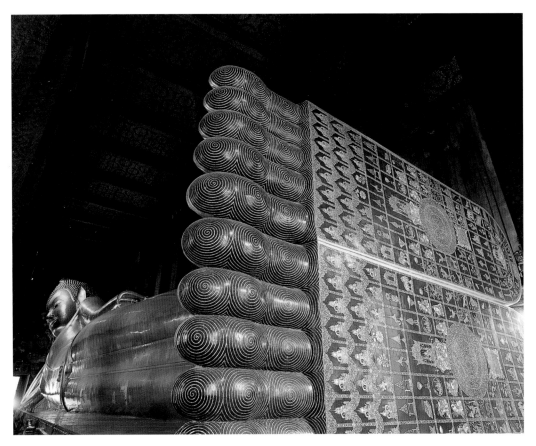

122 & 123. WAT PHRA CHETUPON (WAT PO), Bangkok, Thailand

However many holy words you read,
However many you speak,
What good will they do you
If you do not act upon them?

❁

124. WAT TRAIMIT, Bangkok, Thailand

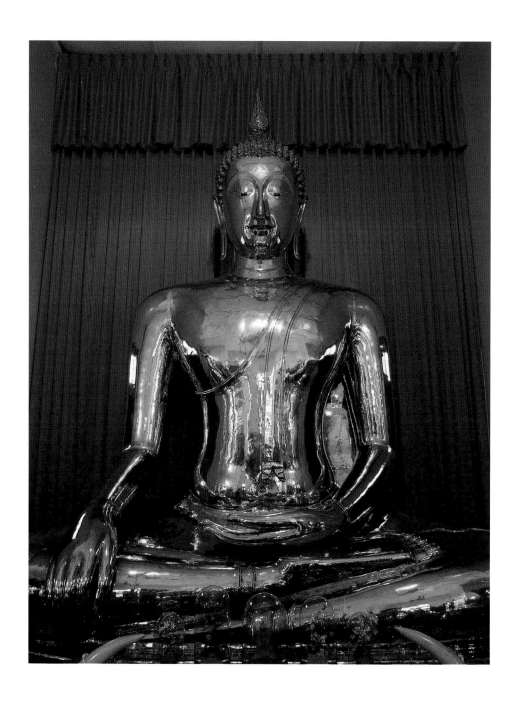

Enlightenment

Few cross over the river.
Most are stranded on this side.
On the riverbank they run up and down.

But the wise man, following the way,
Crosses over, beyond the reach of death.

Free from desire,
Free from possessions,
Free from the dark places of the heart.

Free from attachment and appetite,
Following the seven lights of awakening,
And rejoicing greatly in his freedom,
In this world the wise man
Becomes himself a light,
Pure, shining, free.

As long as people desire Enlightenment
And grasp after it,
It means that delusion is still with them;
Therefore, they who are following
The way to Enlightenment
Must not grasp at it,
And if they reach Enlightenment
They must not linger in it.

❁

125. *Maha Gandha* bell, SHWEDAGON PAGODA, Yangon, Myanmar

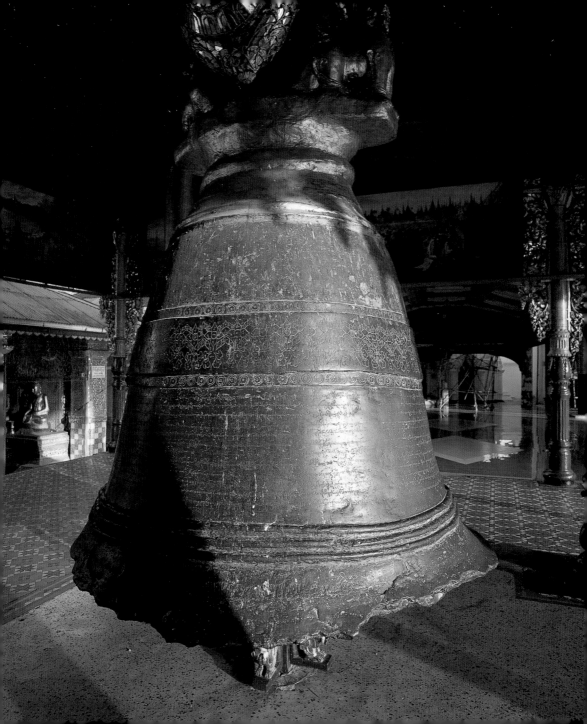

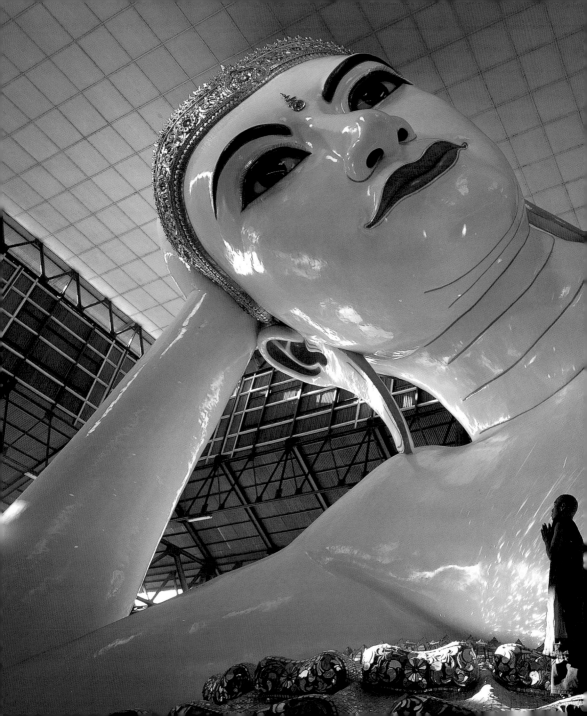

126. Chaukhtatgyi Pagoda,
Yangon, Myanmar

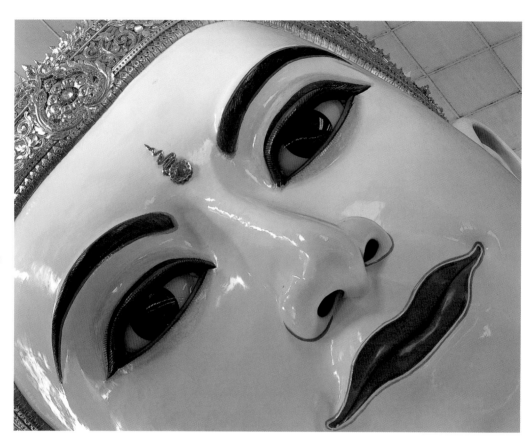

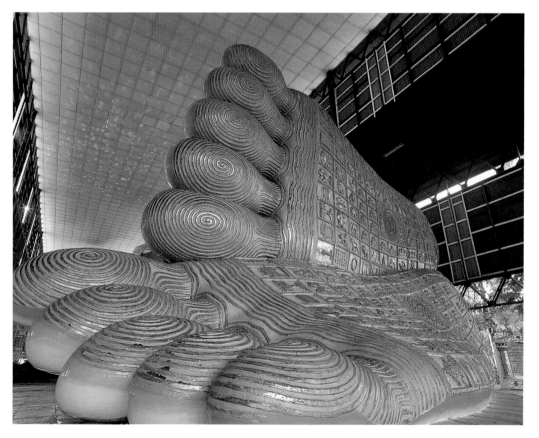

127 & 128. Chaukhtatgyi Pagoda, Yangon, Myanmar

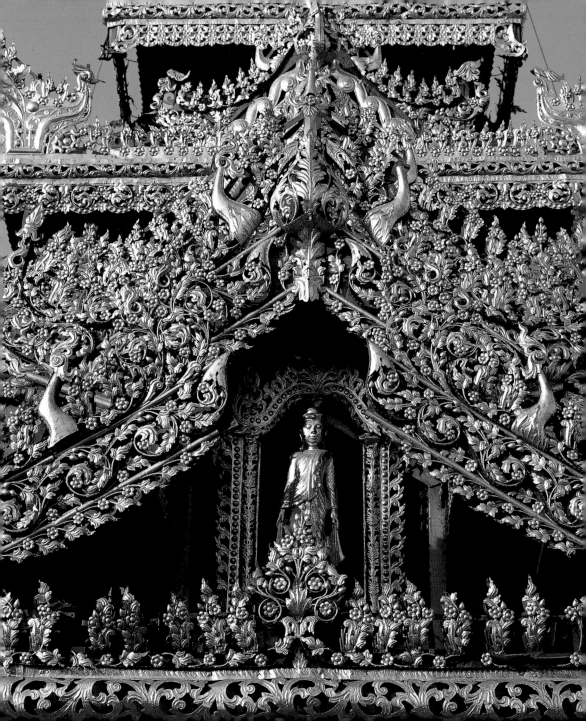

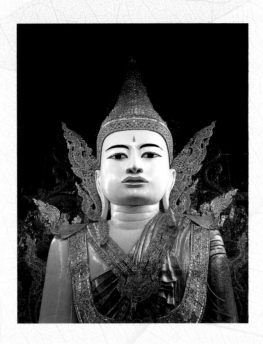

With single-mindedness
The master quells his thoughts.
He ends their wandering.
Seated in the cave of the heart,
He finds freedom.

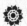

129. SULE PAGODA, Yangon, Myanmar *(opposite)*
130. NGARHTATGYI PAGODA, Yangon, Myanmar

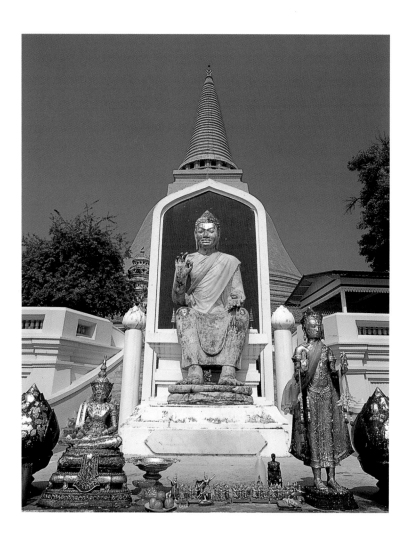

194

131. NAKHON PATHOM CHEDI, Thailand
132. SHWEDAGON PAGODA, Yangon, Myanmar *(opposite)*

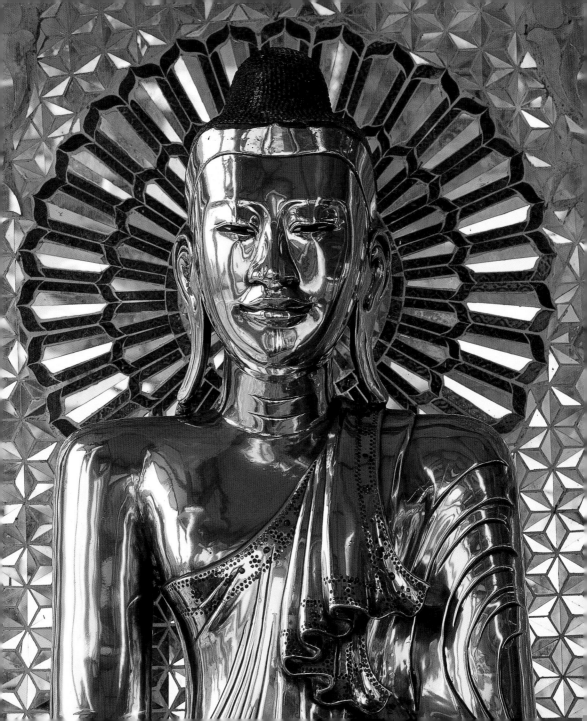

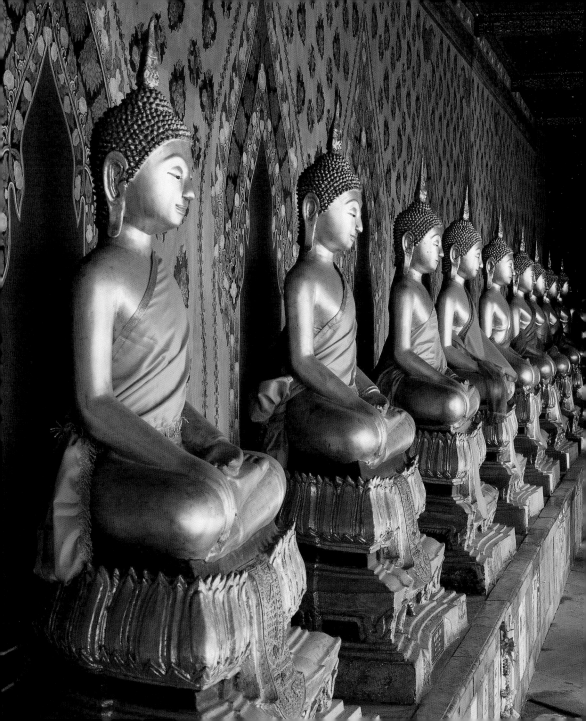

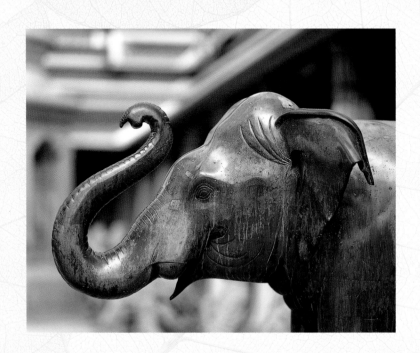

Health, contentment and trust
Are your greatest possessions,
And freedom your greatest joy.

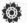

133 & 134. WAT ARUN, Bangkok, Thailand

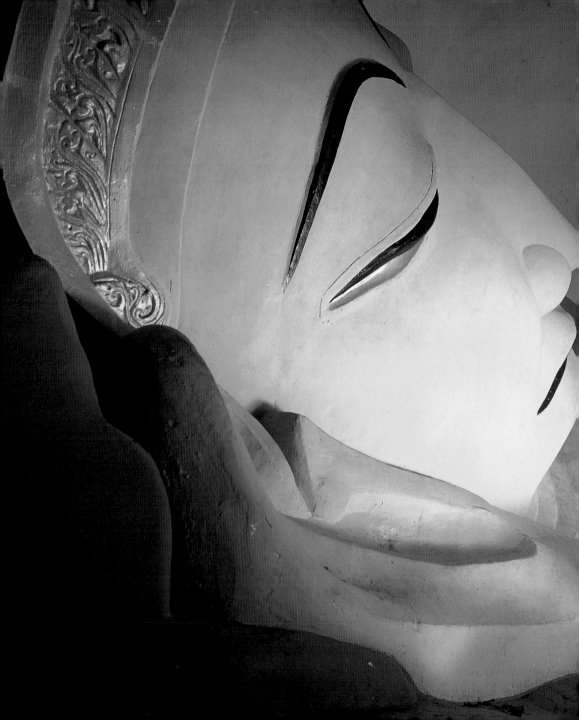

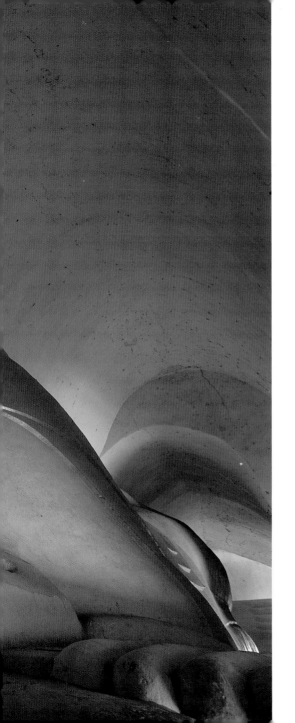

135. SHINBINTHA LYAUNG PAYA,
Bagan, Myanmar

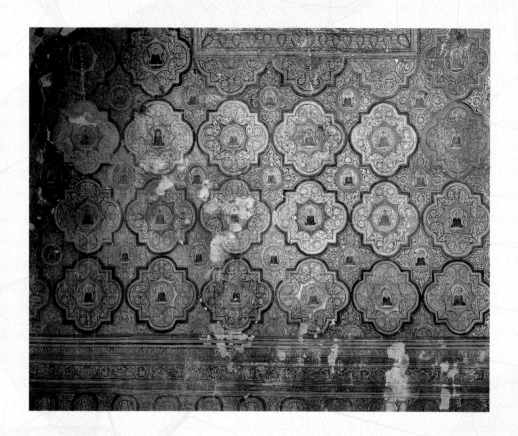

The wind cannot shake a mountain.
Neither praise nor blame moves the wise man.

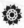

136. Fresco, GUBYAUKGYI PAYA, Bagan, Myanmar
137. HKINKYIZA KYAUNG MONASTERY, Sale, Myanmar *(opposite)*

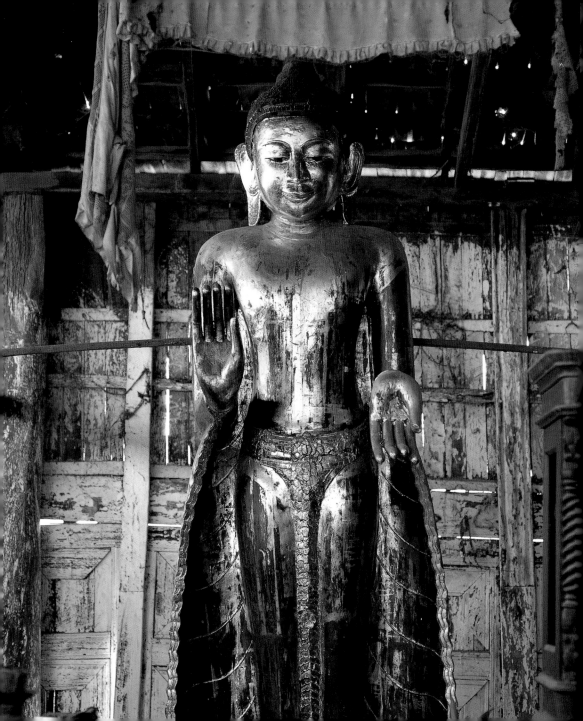

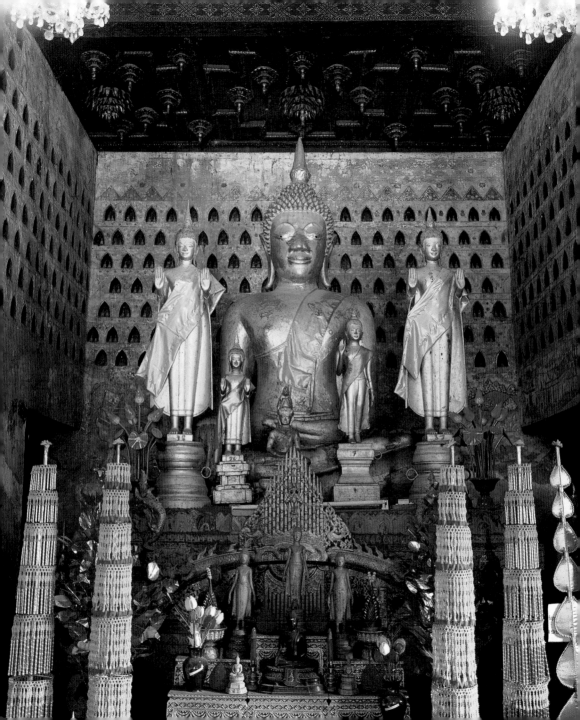

Wakefulness is the way to life.
The fool sleeps
As if he were already dead,
But the master is awake
And he lives forever.

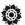

138 & 139. WAT SISAKET, Vientiane, Laos *(opposite and overleaf)*

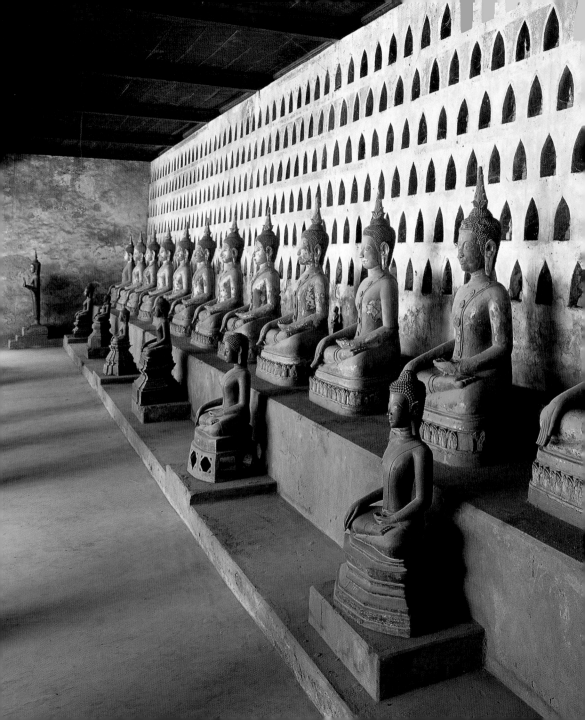

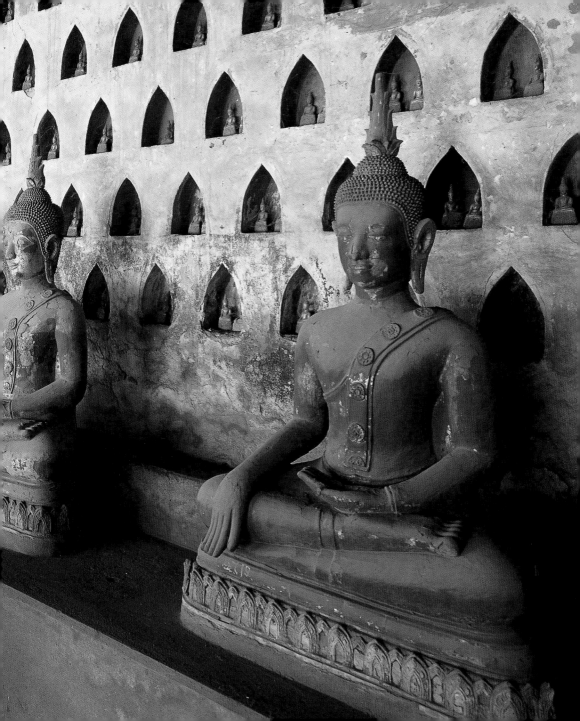

206

140 & 141. WAT PHRA KEOW, Vientiane, Laos

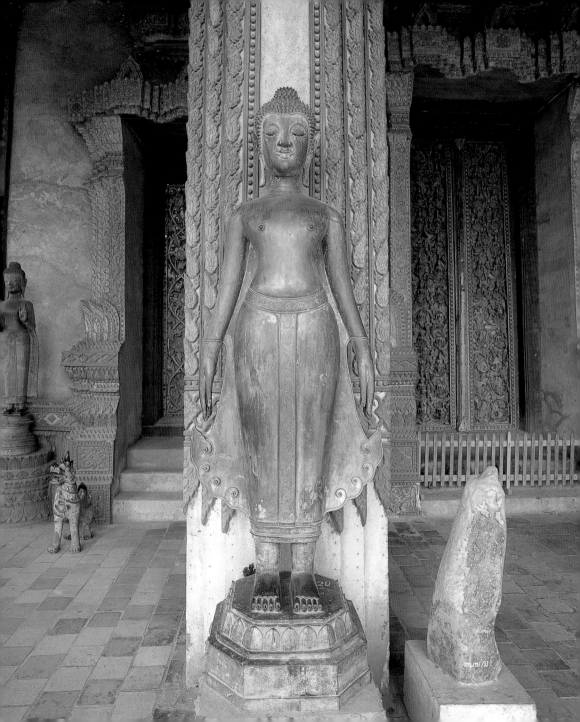

208

142. PHNOM KULEN, Cambodia

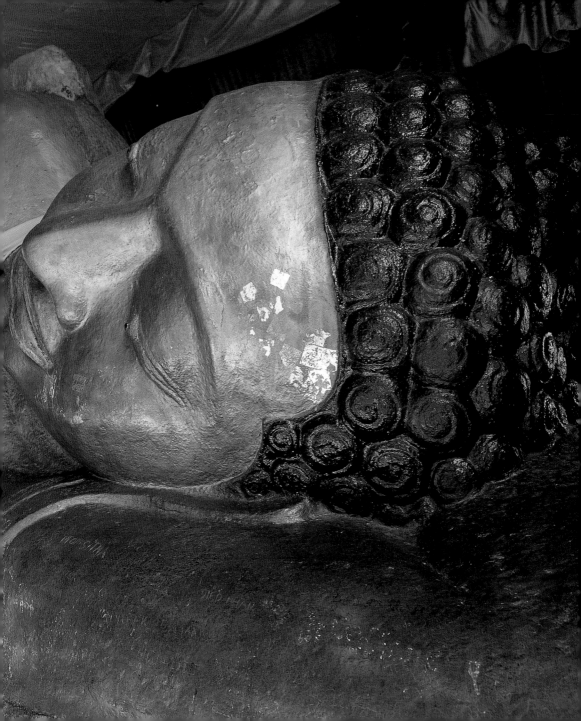

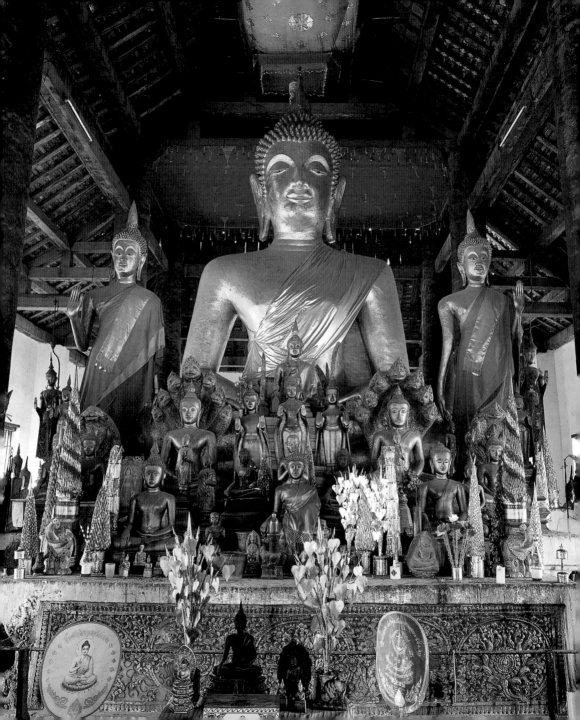

For one who is free from views
There are no ties,
For one who is delivered by understanding
There are no follies;
But those who grasp after views and philosophical opinions,
They wander about in the world annoying people.

143. WAT VISOUN, Luang Prabang, Laos *(opposite)*
144. Lotus carving, BANTEAY SREI, Cambodia
145. SHWEMYINTZU PAGODA, Indawgyi Lake, Myanmar *(overleaf)*

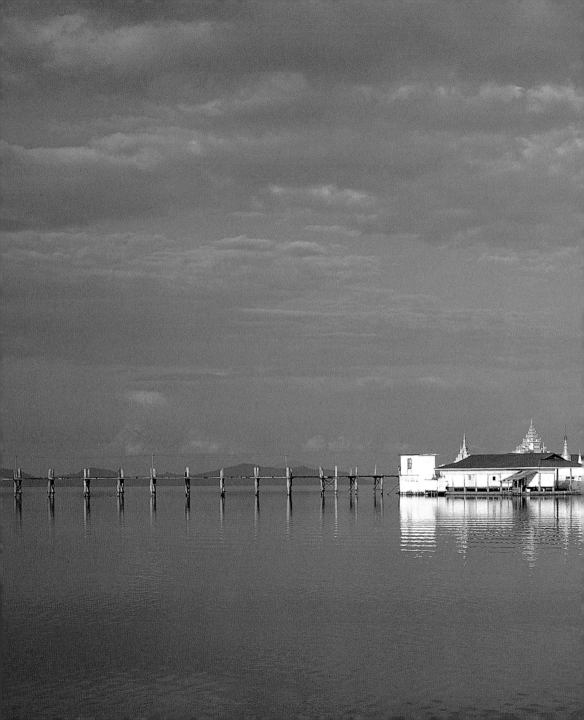

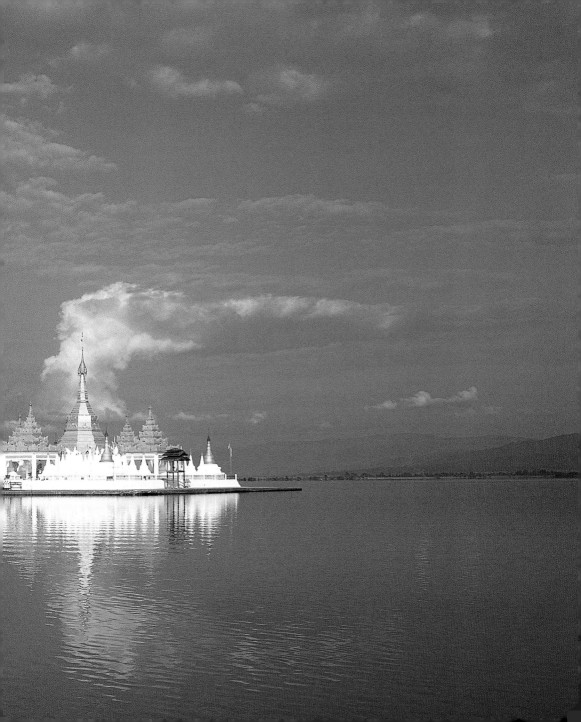

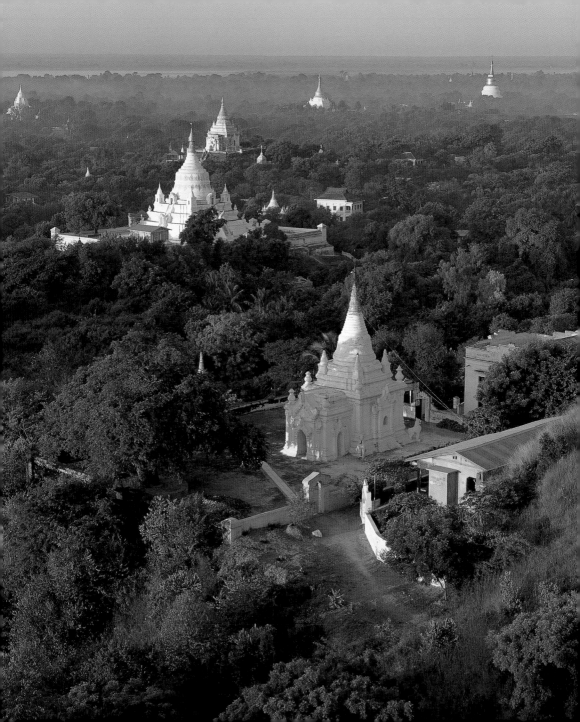

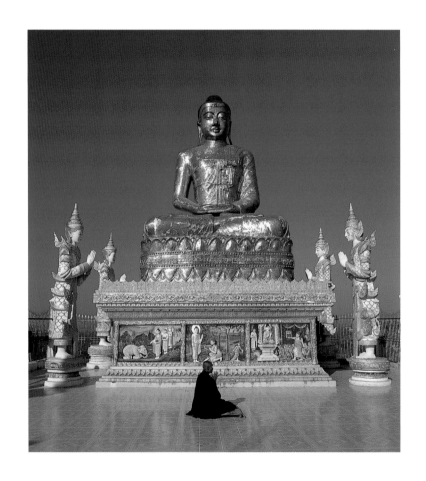

146. SAGAING HILLS, Myanmar *(opposite)*
147. SAGAING, Myanmar
148. ANGKOR WAT, Siem Reap, Cambodia *(overleaf)*

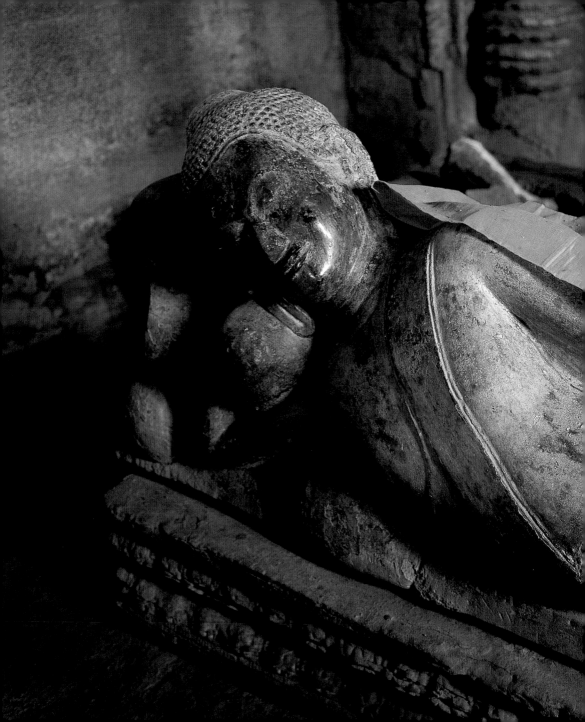

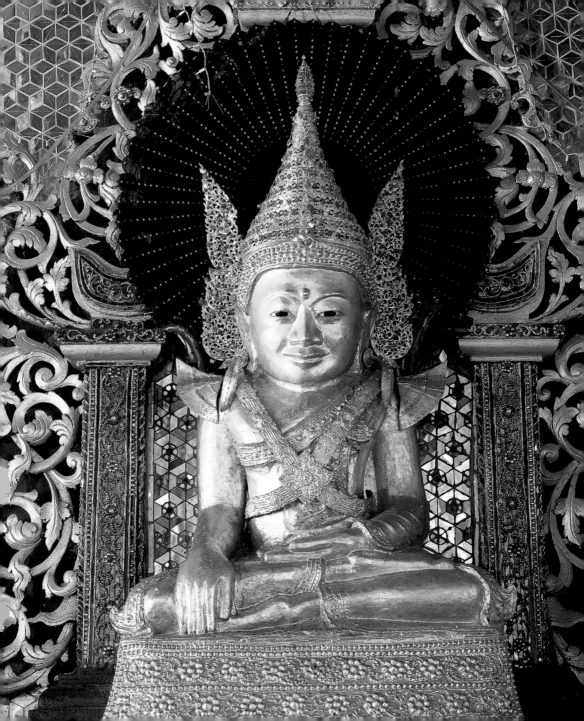

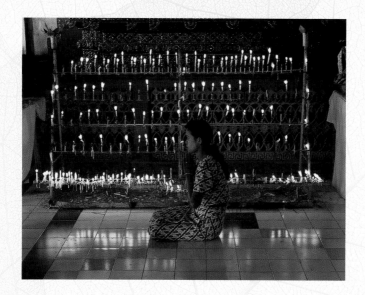

When body and mind dissolve,
They do not exist anywhere,
Any more than musical notes lay heaped up anywhere.

All the elements of being come into existence
After having been non-existent;
And having come into existence pass away.

149. *Rakhine Phar Agri*, MAHA MUNI PAGODA, Dhanyawaddy, Myanmar *(opposite)*
150. MAHA MUNI PAGODA, Dhanyawaddy, Myanmar

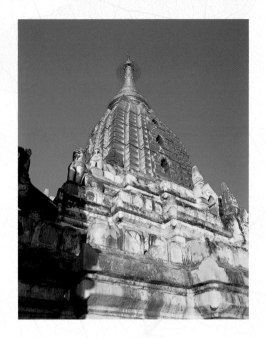

The sage knows the beginning
And end of consciousness,
Its production and passing away—
The sage knows that it came from nowhere
And returns to nowhere,
And is empty of reality,
Like a conjuring trick.

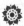

151 & 152. ANANDA PAGODA, Bagan, Myanmar

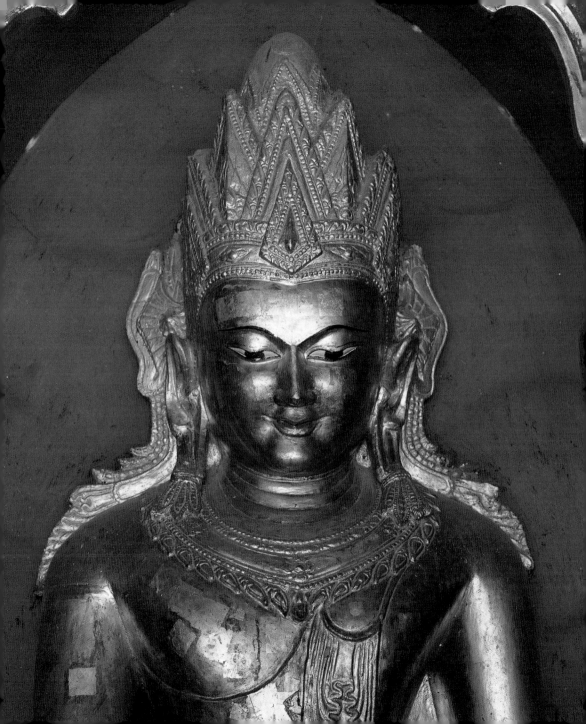

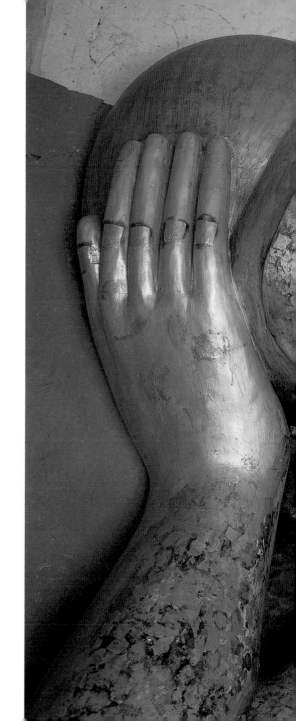

222

153. PO WIN DAUNG CAVES,
near Monywa, Myanmar

As medicine puts an end to sickness,
So Nirvana to all sufferings.

As a mountain peak is free
From all desire to please or displease,
So is Nirvana.

❁

154. MAHA WIHAN, WAT ONG TEU, Vientiane, Laos

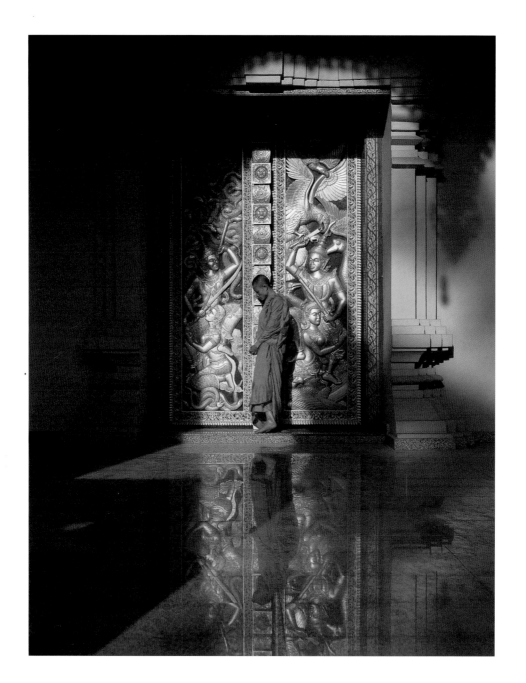

Additional Notes

1. Lotus (page 1)

The Buddha and his achievements were first represented as symbolic icons. The lotus symbolizes his birth and the doctrine of the *dharma*, the path. It stands for the pure state of the enlightened mind that rises from the imperfect and conditioned elements of the material world. The lotus bud is often employed as the penultimate element of a

226 *stupa (see note 41)*. See also images 26, 31, 74, 144.

2. Wat Suthat (page 2)

Mudras are the symbolic positioning of the hands and body which represent the ideals or seminal events in the life of the Buddha. The most common *mudra* is the *bhumispara*, or "earth touching," position, which symbolizes the awakening of the Buddha *(see note 104)*. The gilded bronze Buddha at Wat Suthat is seated in a meditative pose, with his left hand resting in his lap in the *dhyana mudra*. Wat Suthat was constructed by King Rama I to hold the bronze *Phra Sri Sakyamuni* Buddha,

which was salvaged from Wat Mahathat in Sukhothai. The cloisters surrounding the court-yard of Wat Suthat are lined with 156 golden Buddhas. See also images 3, 4, 5, 105.

7. Shwezigon Pagoda (page 22)

Shwezigon contains sacred relics of the Buddha and is second only to Shwedagon in religious significance in Myanmar (formerly Burma). The huge golden *zedi* near the banks of the Ayeyarwady River was built on an ancient site where pre-Buddhist animistic deities known as the *Nats* were worshiped. Shaped like a gigantic bell and over a thousand years old, it sits on a three-tiered base guarded at each corner by a *minothila*, a double-bodied lion.

9. Nanh Paya, Sale (pages 24–25)

Nanh Paya is situated among more than a hundred ruins of ancient religious monuments in the town of Sale. Numerous active monasteries

attest to the unbroken Buddhist traditions that survive and flourish there. The thirteenth-century Nanh Buddha is one of the largest lacquer images in the world.

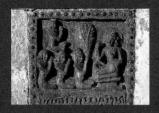

10. *Jataka* plaques (page 26)
As early as the second century B.C., the 550 tales of the previous lives of the Buddha known as the *Jataka stories* were circulating throughout the Buddhist world. In them, the historic Buddha is just one in a series of enlightened beings, repeatedly being born to reveal the truth of existence, the *dharma*, to all mankind. Parables illustrate the noble Buddhist virtues of generosity, compassion, and self-sacrifice, as well as the principles of *karma* and right actions that lead to the final liberation attained when one reaches *Nirvana*. The Ananda Temple is the only shrine in Bagan to have a complete set of glazed *Jataka* plaques, which are set into the walls of the upper terraces surrounding the central spire.

12. Ananda Pagoda (page 27)
The Ananda Pagoda has been in continuous use since the twelfth century, when it was the center of Buddhist scholarship in Bagan. Entering one of the wide porches aligned with the cardinal directions, the devotee passes through a vestibule flanked by huge wooden doors and walks along two long galleries inset with hundreds of niches containing Buddhas. The culmination of this mystical experience is the holy sight of the four 31-foot-tall gilded teak images representing the last four reincarnations of the Buddha. This south-facing Buddha dates from the origins of the temple, around 1105, and is portrayed in the *dharmachakra mudra*, arms folded across the chest, hands in front of the heart, and fingers in the shape of a circle symbolizing the turning the wheel of the *dharma*. See also images 6, 10, 49, 67, 151.

15. Inwa (page 31)
The vast, walled city of Inwa was founded by King Thado Minba in 1364 and became the capital of central Myanmar for nearly five hundred years. Magnificent wooden palaces, monasteries, and golden *zedis* were built upon an artificial island at the confluence of the Ayeyarwady and Dokhtawady Rivers. A massive earthquake rocked Inwa in 1838, toppling many of the monuments. The city's inhabitants subsequently abandoned it, leaving hundreds of magnificent shrines and monuments to the ravages of time.

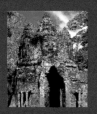

16. Angkor Thom (page 32)

The twelfth-century royal capital of Jayavarman VII, Angkor Thom, was the one of the largest and most magnificent of all Khmer cities. At its geographic center was the Bayon Temple, which represented the mythical center of the Buddhist universe, Mt. Meru. A 7.5-mile-long wall, symbolizing the mountain chain surrounding Meru, defined the 10-square-mile sacred space. The wall was pierced by five gates, which could be closed at night with huge wooden doors. Each gate was 75 feet tall to allow elephants topped by royal parasols to pass through. The gates were surmounted by three peaks, each carved with a face of the Buddha as the incarnation *Avelokitesvara*, the Bodhisattva of compassion. See also images 18, 33, 34, 66.

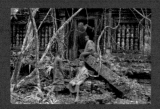

17. Beng Mealea (page 33)

Beng Mealea, constructed in the mid-twelfth century, was likely the prototype for Angkor Wat and other later Buddhist shrines built by the Khmer kings. Situated below the eastern flank of the sacred Kulen Mountains, the temple-fortress was surrounded by a huge moat with four great causeways, concentric courtyards, and a massive central sanctuary covering an incredible 267 acres making it one of the largest religious structures in the world. It is currently completely subsumed by jungle vegetation but the World Monument Fund is about to undertake a major renovation.

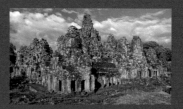

18. Bayon (pages 34–35)

The Bayon temple was the twelfth-century Khmer empire's ritual masterpiece, an earthly representation of Mt. Meru, mythological center of the universe. One of the few monuments at Angkor which was conceived purely as a Buddhist shrine, the devotee circles a central tower *(see note 41)* while ascending the monument, finally reaching a platform on the top level, which is the home of the divine. Thirty-seven of its original forty-nine towers are still standing, and over two hundred colossal faces of the Bodhisattva *Avelokitesvara* represent compassion projected out to the cardinal directions. See also images 16, 33, 34, 66.

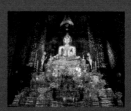

19. Wat Bowonivet (page 36)

Tucked away on a side street in the old section of Bangkok, in the hush of the opulently decorated

sanctuary of Wat Bowonivet, are two of the finest bronze Buddhas in the world. Arranged in tiers, the images are the epitome of the refined art produced during the thirteenth century in Sukhothai. It is the Thai custom for all kings to spend time as monks before ascending the throne—in the case of King Rama IV, for 27 years. This is the traditional Wat, where a succession of kings, including the current King Rama IX, have been ordained into the Theravada order. See also image 20.

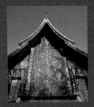

21. Wat Xieng Thong (page 38)
The most important royal temple in Luang Prabang is Wat Xieng Thong, which houses the library of Buddhist teachings, called the *Tripitaka (see note 82)*, and numerous important pieces of Buddhist art. Built in 1559 upon the banks of the Mekong River, the temple's exterior features colored mirrored-glass mosaics set into red stucco backgrounds, the most famous being the *Thong Copper Tree* mosaic. See also images 23, 24, 50.

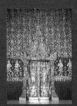

23. Luang Prabang (page 40)
Luang Prabang was the first royal capital of the Lane Xang kingdom. Founded in 1353, it was

built at the confluence of the Mekong and Khan Rivers. Members of the Hmong, Mien, Thai, and other hill tribes can be seen in the markets and nearby villages, reflecting the capital's multi-ethnic surroundings. First opened to tourism in 1989, thirty-two of its sixty-six Buddhist temples, built before French colonization, are still standing. Described by UNESCO in 1994 as the best-preserved city in Southeast Asia, Luang Prabang was designated a World Heritage Site in 1995. See also images 21, 24, 26, 27, 92, 117, 143.

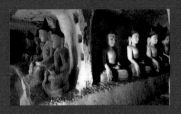

29. Po Win Daung Caves (pages 46–47)
The discovery of 30-million-year-old fossils has revealed that the Po Win Hills have been inhabited since the dawn of mankind. Undoubtedly, the great many natural caves found here were used as primitive habitations. Buddhist monks began to occupy the site more than two thousand years ago and started excavating new caves and enlarging old ones. Over the centuries, four hundred thousand images have been preserved here. The Buddhas were made of wood, lacquer, and gold and many others were carved from the living rock. The walls were covered with detailed frescoes and mosaics of colored glass. Today, it remains a forbidding and remote location populated by wild monkeys, cobras, and scorpions, which seek out the cool, dark environs of the caves. See also images 28, 153.

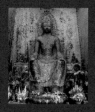

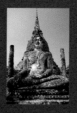

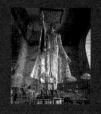

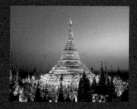

30. Ayutthaya (page 48)

A masterpiece of stone sculpture, the huge 1300-year-old *Dvaravati*–style Buddha known as *Phra Kantharat* was brought from Nakhon Pathom by King Rama III. Now residing in its own small *viharn*, or chapel, next to the main shrine of Wat Na Phra Men, it is seated on a throne in the *pralamban asana*, hands on knees and feet resting on a lotus. See also images 88, 91, 131.

40. Sukhothai (page 65)

Sukhothai, flourished between the thirteenth and late fourteenth centuries, fostering the golden age of Thai culture and providing some of the most inspired Buddhist art and architecture in the world. The artisans of Sukhothai were the first to portray the Buddha in four classic positions: seated, standing, walking, and reclining. The remains of Sukhothai's forty temple complexes and almost two hundred *chedis* have been designated a UNESCO World Heritage Site. See also image 70.

38. Mandalay Hill (page 63)

During his life as an itinerant teacher the Buddha came to a small mountain in central Myanmar where he prophasied that a great royal city would be built 2400 years in the future. In 1857, King Mindon Min moved his capital from the banks of the Ayeyarwady River to Mandalay, fulfilling the Buddha's ancient prophesy. At the summit of the hill, he placed Shweyattaw, a huge standing image covered with gold, its right arm outstretched, pointing to the site of the future royal palace. Mandalay Hill, still graced with numerous Buddhist shrines, remains an important pilgrimage place.

41. Shwedagon Pagoda (pages 66–67)

The venerable Shwedagon Pagoda, with its 326-foot-tall *zedi* covered with sixty tons of gold, is a spiritual focal point for Asian Buddhists, and a radiant symbol of Buddha's enlightenment. The *zedi*, also known as a *stupa* or *chedi*, is used as a reliquary for the physical remains of the Buddha—in this case, eight hairs—and those of other spiritual masters. The relics contained inside are regarded as precious seeds from the past, used to inspire devotees. The *zedi* also receives and focuses mental energy from the *mantras* and meditations of pilgrims, amplifying and transmitting them

outward. Pilgrims walk around the monument in a clockwise direction known as *circumambulation*, while repeating *mantras*. They stop to pay their respects to the many images of the Buddha, the finest of which are sheltered in four porches aligned with the cardinal directions. See also images 7, 53, 58, 73, 80, 96.

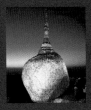

46. Kyaiktiyo (page 73)

A Burmese legend describes a gigantic boulder that was shaken loose, rolled down a mountainside, and mysteriously stopped at the very edge of a cliff. When the Buddha made a pilgrimage to the renowned site, he honored it by offering a hair from his head, which he placed under the rock. The enormous boulder has remained for centuries, surviving numerous earthquakes, precariously perched and still rocking ever so slightly from side to side. Millions of pilgrims have venerated the *stupa*-shaped stone by applying sheets of gold leaf. See also images 41, 103.

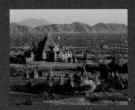

51. Bagan (pages 80–81)

Bagan was founded in ninth century and lasted until 1287. It was the cultural and religious capital of more than twenty kings, and remained the seat of advanced Theravadin art, architecture, and philosophy for over a millennium. More than two thousand religious monuments still exist on the plains of Bagan along the banks of the Ayeyarwady River. Dhammayangyi, an architectural masterpiece that has withstood numerous earthquakes, is one of the largest and best-preserved temples. See also images 5, 14.

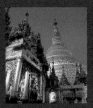

58. Shwedagon (page 90)

Legends recount that in the sixth century B.C., Burmese traders in northern India met the historic Buddha. From his head he gave them eight hairs, which they carefully protected and transported back to Myanmar. On top of Singuttara Hill was an ancient meditation cave, where they enshrined the precious objects, building a *zedi* on top. Widely regarded as the most beautiful Buddhist temple in the world, it is also the richest, lavishly covered with gold and precious gems. Today, as in the past, the air is filled with the sound of over one thousand silver and gold bells and the perfume of incense and flowers. The golden *zedi* is ringed by more than one hundred additional shrines containing a treasury of Burmese art and architecture. See also images 36, 41, 59, 61, 63, 114, 119.

65. Wat Rajabopit (page 101)

The elaborate mother-of-pearl inlaid doors and window shutters of Wat Rajabopit display some of the finest craftsmanship in Thailand. In this time-consuming art form, small pieces of turban shell are cut, shaped, and inlaid into multiple layers of lac, the resinous sap of the sumac tree. The layers are dried and polished to reveal complex miniature scenes, which glow with rainbow iridescence against the black background. In this section, praying celestial maidens are surrounded by *nagas*—stylized snakes—and vegetation from the mythical *Himavata Forrest*.

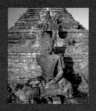

69. Mrauk U (page 106)

The kingdom of Arakan began its recorded history in the fourth century B.C. and eventually grew into a powerful commercial empire that engaged in extensive trade, not only with its neighbors Myanmar and India, but also with distant nations in Europe and the Middle East. Arakan also became a great religious center, visited by monks from India, Bengal, Sri Lanka, and Tibet. Founded in 1433, the capital, Mrauk U, reached its zenith in the sixteenth century. This period saw the construction of hundreds of huge and architecturally complex religious monuments, of which about seventy remain. See also images 35, 52.

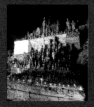

68. Pak Ou Caves (page 105)

The caves of Pak Ou are situated high upon limestone cliffs that rise at the confluence of the Mekong and Nam Ou Rivers, north of Luang Prabang. Originally used to venerate *Phi*, or animistic spirits, they were subsequently filled with thousands of images brought there for safekeeping during ancient wars and troubled times. Many of these Buddhas are rare wooden images displaying the distinctive Lao *mudra* "calling for rain," with arms at sides and palms facing inward.

71. Monks begging for food (page 108)

The *Sangha* is the monastic order that provides the optimal conditions for spiritual development. Monks undertake a spartan life of celibacy, poverty, and non-violence. Before dawn they begin their rounds, carrying alms bowls and giving laypeople the opportunity to earn merit by providing for the monks' one meal of the day. Monks have traditionally been wandering teachers, living in caves and meditating solitarily in the forest,

attached to any specific monastery except during the rainy season. Most of their time is devoted to meditation and to the study of religious texts, but they also perform ceremonies for the milestones of birth, novitiation, marriage, and death. See also images 8, 39, 56, 75, 97, 115.

72. Sri Ksetra (page 109)

Sri Ksetra, the first capital of the Pyu people, was founded by King Duttabaung over two thousand years ago. During the height of its development, from the third through tenth centuries, there were over one hundred active monasteries and numerous imposing religious monuments. Vestiges of crumbling walls and foundations outline what remains of the once great kingdom, which was destroyed in 1057. The overgrown ruins cover a vast area and include several gigantic cylindrical *stupas*, such as the 150-foot-tall Bawbawgyi, which is being worshiped here by a solitary monk.

76. Kyaikhami (pages 116–117)

On the southern coast of the Gulf of Mottama is a shrine whose location on the shore is never touched by the sea, due to a unique combination

of crosscurrents and tides. Legends tell of a Sri Lankan monk who incorporated pieces of the original *Bodhi* tree *(see note 97)* into statues of the Buddha, which he set adrift on wooden rafts upon the ocean currents. Miraculously four made the voyage safely, landing at Kyaikhami, Pathein, Kyaikto, and Dawei.

77. Maha Muni (page 119)

The colossal Maha Muni Buddha is believed to be the only image of Siddhartha Gautama cast during his lifetime, when he visited the kingdom of Arakan in 554 B.C. It was enshrined there until 1784, when a rival Burmese King went to war to obtain the powerful icon and carried it by elephant across mountain ranges to his capital, Amarapura, in central Myanmar. Eventually it was moved again, to an opulent temple in nearby Mandalay, where it remains. The image, cast by alchemists using an alloy of five metals, is encrusted with hundreds of pounds of gold and precious gems, donations that confer spiritual merit upon the givers. *Maha Muni* is reverentially treated as if alive, his face ceremonially washed at four each morning, his teeth brushed, and his body dressed in monastic robes during the rainy season. See also images 113, 149, 150.

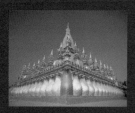

78. Wat Phra That Luang (pages 120–121)

Built by emissaries of the Indian Emperor Ashoka in the third century B.C., Wat Phra That is the most important religious site in Laos. Its present configuration, dating from 1566, incorporates Laotian design elements such as a central spire in the shape of a lotus bud and a wall made up of 120 huge lotus petals. Thirty smaller *stupas* surround the three-tiered pyramid. See also image 50.

82. Buddhist scriptures (page 125)

For three hundred years after the death of the Buddha, no written records of his teachings were made. Instead, a School of Reciters transmitted his wisdom orally. It was not until 200 B.C., and continuing through the year 600, that his followers began to carefully write down many of his important teachings. What survives today is known as the *Tripitaka*, or the Three Baskets, which include the monastic rules, or *Vinaya*; the *Suttras*, or discourses; and the *Abdhidhama*, the advanced doctrines. At the foot of Mandalay Hill is the Kuthadaw Pagoda, where marble tablets inscribed with the entire *Tripitaka* are enshrined in 729 *Pitaka* Pagodas. "The world's largest book" was copied from the original palm-leaf manuscripts by 2400 monks, who took eight years to complete the task. It is the goal of every monk to memorize the *Tripitaka* in its entirety, but out of the current 300,000 monks in Myanmar, only five have been able to do so. It takes about two years for a single monk to recite it from beginning to end. See also image 56.

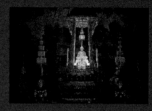

83. *The Emerald Buddha* (page 126)

The most revered object in Thailand, the Emerald Buddha was carved from a single piece of deep, green Jade. Its long and convoluted history began in 1436, when lightning struck a *chedi* in Chiang Rai, Thailand, and cracked it, revealing a plaster Buddha inside. As the plaster flaked away, an exquisite jade image was exposed. Treasured and fought over by Thai and Lao kings, it was taken to Vientiane, Laos, were it resided for more than two hundred years. In 1778 it was returned to Thailand and was eventually installed in the Grand Palace complex in Bangkok. Seated in a meditative pose, the figure wears various robes, which may only be changed by the king. A gilded monk's robe is used for the rainy season, a solid gold one for winter, and a diamond-studded robe for summer. The statue is the symbol of the sovereignty of the kingdom, and is the centerpiece for the holiest shrine in Thailand.
See also image 141.

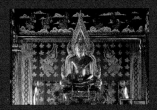

86. Chiang Mai (page 129)

Thailand's second most important city, Chiang Mai, is situated on the banks of the Ping River. Founded in 1292 as the capital of the ancient Thai Lanna Empire, it was ruled by a succession of twenty monarchs for over 240 years. More than three hundred temples were constructed in the empire between the thirteenth and mid-sixteenth centuries. Isolated by rugged mountains and dense jungle, the Thai Lanna kingdom developed its own distinct style of art and architecture.

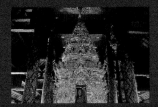

88. Lampang Luang (page 132)

Lampang Luang is perhaps the most beautiful and significant shrine in northern Thailand. The current Wat dates from the late fifteenth century, but its origins go back to the eighth century. The teak-wood Lanna–style *viharn*, or main assembly hall, is open on four sides, its interior walls painted with murals. The pillars are covered with black lacquer and stenciled with gold-leaf patterns. The *Phra Chao Lang Thong* Buddha is situated in an ornate *ku*, a northern Thai enclosure made of brick and stucco and covered in gold leaf. Within a nearby *viharn* dating from 1802, sits another Buddha, over

16 feet tall *(see image 106)*. Also within the courtyard is one of the oldest wooden structures in Thailand. See also image 107.

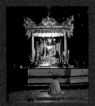

97. Shwedagon (page 143)

After leaving his father's palace, Siddhartha wandered for six years, practicing meditation and the extreme yogic penance of an ascetic. He sat under the shade of a pipal tree, *Ficus religiosa*, vowing to remain until he achieved *Nirvana*. Since that time, the tree—and its foliage—has represented enlightenment, and is commonly referred to as the *Bodhi* tree, the tree of awakening. See also images 98, 104. 235

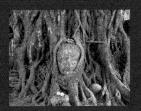

98. Ayutthaya (pages 144–145)

Roots of a *Bodhi* tree, *Ficus religiosa*, engulf a fourteenth-century stone image of the Buddha from the kingdom of Ayutthaya. Ayutthaya became the most powerful kingdom in Siam and was filled with magnificent temples and palaces. Foreign traders who visited during the sixteenth century wrote of the splendor of golden temples and a city filled with sophisticated art. In 1767, following years of decline, Ayutthaya was sacked by the Burmese. See also image 97.

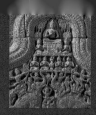

104. The Attack of Mara (page 153)

After leaving his father's palace, Siddhartha traveled deep into the forest, cut his hair, and took the vows of a wandering Hindu ascetic. He practiced severe yogic austerities until he realized that extreme physical mortification would not bring him to enlightenment, so he sought a Middle Way. As told in a legend, while the Buddha meditated on the truths of existence, the god Mara tried to prevent his enlightenment by attacking with armies and the temptations of his daughters. Siddhartha touched the ground with his right hand and declared the earth as witness that his *karma* from previous lives entitled him to liberation. He continued his deep meditations throughout the night and achieved *Nirvana* the next morning. From then on he was called the Buddha, or the "one who has awakened." See also image 97.

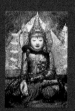

110. Yadana Labamuni Pagoda (page 163)

The snake has had important religious and symbolic significance throughout Asian history, from the pre-Buddhist worship of *nagas* as protective spirits to the legend of the cobra Muscilinda, who saved the Buddha from floodwaters by coiling under his body and sheltering him with its hood. Since prehistoric times, snakes have been worshiped as controllers of the monsoon rains and guardians of the riches of the earth. Unlike the Western concept of the snake as an evil denizen of the underworld, the Hindu and Buddhist notion of the snake is as an entity to be protected and venerated. In the distant past, the Yadana Buddha image was lost. When rediscovered overgrown with jungle, two large pythons were coiled protectively around the statue. A new shrine was built nearby to house the image, taking great care to bring along the huge snakes, which have remained there ever since. In observance of the non-harming principle, the snakes are fed only eggs. See also images 65, 101.

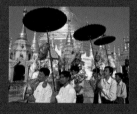

116. *Shin Pyu* ceremony (pages 170–171)

In Myanmar and other Theravadin Buddhist countries, children begin their novitiation between their ninth and twelfth birthdays. At this time, which symbolizes the end of childhood, each novitiate becomes a "son or daughter of Buddha," is entrusted to the monks, and enters the monastic order. In the *Shin Pyu* ceremony, the children dress in the sumptuous garments of the prince Siddhartha and reenact his renunciation of worldly possessions. The ceremony culminates in the shaving of the head—and the piercing of the ears for girls—after which the participants receive *Pali* names and are taught the important Buddhist scriptures and ten basic rules of conduct. Although

most leave the monkhood by their twentieth birthdays, they consider this the most important part of their religious life.

astonishment of all, revealed a spectacular five-ton golden Buddha, one of the largest solid gold objects in the world.

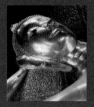

122. Wat Phra Chetupon (Wat Po) (page 180)
This gigantic 148-foot-long gilded brick-and-stucco reclining Buddha completely fills its *viharn*, overwhelming the visitor. Originating in the sixteenth century, Wat Po is Bangkok's most venerable temple complex, containing the largest collection of Buddha images in Thailand. On the soles of the figure's feet, finely rendered in mother-of-pearl inlay, are the 108 auspicious signs of the Buddha, physical characteristics that designated Siddhartha as a supernatural being and Buddha-to-be. See also image 128.

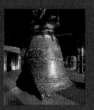

125. Bell at Shwedagon Pagoda (page 187)
The bell has been an important symbol of higher consciousness throughout the history of Hinduism and Buddhism. The nature of sound has been compared to the cosmic vibrations that manifest the physical universe. Sound waves created by the bell are thought to raise consciousness and dispel ignorance, resonating in the mind like a *mantra*. The *zedi*, or *stupa*, is shaped like a bell to tune and amplify the meditations of pilgrims, and the wisdom and truth of the *dharma* is thought to vibrate through the eons of time to awaken mankind.

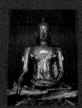

124. Wat Traimit (page 183)
A large but rather ordinary plaster Buddha was located in a temple in a back alley of Bangkok. In 1953 the land was sold, and an attempt was made to move the Buddha to a new *Wat*. When a construction crane tried to lift the Buddha, the weight caused it to crash to the ground. The powerful impact cracked the plaster and, to the

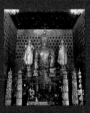

138. Wat Sisaket (page 202)
The oldest temple in Vientiane is designed with cloisters that are lined with small niches representing meditation caves. There are an astounding 6840 Buddhas at Wat Sisaket, including thousands of silver and ceramic Buddhas in miniature retreats, and 300 seated and standing Buddhas in the cloisters. The *sim*, or central sanctuary, contains

a large seated Buddha flanked by two standing Buddhas displaying the *abhaya*, or "freedom from fear," *mudra*. The ceiling is covered with gold flowers and lotus buds, and the walls are painted with *Jataka* murals. See also images 10, 139.

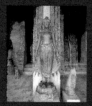

141. Wat Phra Keow (page 207)

Originally built by King Settathirat in 1560 as his personal place of worship, this temple became the home of the famed Emerald Buddha (now in Bangkok), symbol of religious and political sovereignty for the Thai Lanna kingdom. It was severely damaged in 1827 and abandoned until 1860, when Francis Garnier rediscovered it as an overgrown ruin. Restored in the 1950s, the shrine is embellished with ornate plaster decorations, deeply incised wooden doors, and mirrored-glass mosaics.

142. Phnom Kulen (pages 208–209)

The Kulen Mountains represent the sacred Himalaya, dwelling place of the Khmer gods, and have always been a favorite haunt of holy men. Actually a great sandstone plateau laced with waterfalls and punctuated by peaks and rocky escarpments, it is the source of the Siem Reap River, the Cambodians' symbolic equivalent to the life-sustaining Ganges. Site of one of the first royal capitals created by Jayavarman II, in the year 802, Phnom Kulen became the birthplace of the Khmer Empire. At the summit of Kulen is the largest reclining Buddha in Cambodia, a 900-year-old figure carved from a single massive boulder. See also image 16.

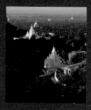

146. Sagaing (page 214)

The Sagaing hills rise steeply from the western banks of the Ayeryarwady River. Long considered the center of living Buddhist faith in Myanmar, the hills provide a refuge for more than six hundred active monasteries and three thousand monks and nuns. There are hundreds of unique *zedis* and cave shrines excavated into the cliffs, which are connected by stone pathways shaded by ancient Plumeria and Tamarind trees. See also 64, 75, 100, 147.

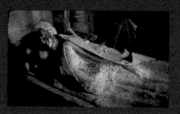

148. Angkor Wat (pages 216–217)

Angkor Wat is the greatest achievement of the Khmer Empire and the largest temple in the world. Although it was conceived as an earthly representation of Mt. Meru, symbolic center of the

Hindu universe, and was originally dedicated to Vishnu, it became a Buddhist shrine in the fourteenth century when the king of Cambodia converted to Theravada. One of the interior cruciform galleries became "The Hall of a Thousand Buddhas" and the four vestibules of the central sanctuary, where this reclining Buddha lies, were turned into Buddhist shrines.

eighteenth century and rebuilt in the nineteenth and twentieth centuries. Before contemporary times, Buddhist monasteries provided the only education available. Although the state now provides formal education for its citizens, monks are still highly respected as teachers and are consulted on a wide variety of practical issues.

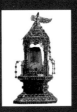

155. The Peshawar Relics (page 240)

The historic Buddha, Siddhartha Gautama, died in 486 B.C. at the age of 80 in Kusinara, India. Near the end of his cremation ceremony a monsoon rain extinguished the flames, leaving several bones and teeth among the ashes. These precious body relics were handed down from the Buddha's followers through a succession of royal families. In the year 630, three of the bones were placed in a carved crystal reliquary inside a golden casket, which was then entombed in a 551-foot-tall *stupa* outside of what is today Peshawar, Pakistan. Over the following centuries, all traces of the stupa were destroyed, and the Peshawar Relics were lost for more than a thousand years. Incredibly, during an excavation in 1908, Dr. D. B. Spooner of the Archeological Survey of India rediscovered the golden casket containing the Buddha's remains. The relics are now protected and highly venerated by the Burmese *Sangha*.

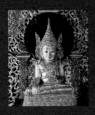

149. *Rakhine Phar Agri Buddha* (page 218)

Maha Muni Pagoda was built upon the site of Dhanyawady, the fourth-century capital of the kingdom of Arakan. The Buddha image sheltered here, known as Maha Muni, "Great Sage" was believed to be the source of the kingdom's power and success. After rival kings stole the statue in 1784 and took it to central Myanmar, the broken-hearted Arakanese made a diminutive copy to take its place. The copy is commonly called "little brother Maha Muni." See also 77, 94, 113, 150.

239

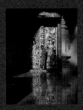

154. Wat Ong Teu (page 225)

Wat Ong Teu is part of the most important Buddhist school in Laos. Although worship at this site dates from around 1500, the *Wat* was destroyed in the

Acknowledgments

I am deeply grateful to many individuals for their belief in the artistic merit of the photographs and the spiritual and cultural importance of the work.

MARTHA MCGUIRE has been lovingly devoted to me, the photography, and our business for 25 years. She offered her time and wide range of abilities, from facilitating travel, doing PR, to running our office. She edited a huge amount of images and text, scanned and organized the material, came up with structural ideas, and patiently wrote captions.

LENA TABORI, publisher and god-mother to artists, is unafraid to publish books that she feels can make a difference. She gives her time and love generously and manages to find a way to make our passions financially viable.

ALICE WONG, project director, is the calm, organized center of Welcome, unifying the team and keeping the project on schedule. She clarified and greatly improved the structure and content of the book.

GREGORY WAKABAYASHI, designer extraordinaire, transformed an idea into a sophisticated manifestation without losing the simplicity of the theme. He intuitively solved the structural and sequencing challenges.

NAOMI IRIE, project assistant, worked diligently behind the scenes, picking up all the loose ends.

JACK KORNFIELD's humble persona and focus on bringing the teachings to a wider audience are the embodiment of Buddhist principles.

THOMAS BYROM's fresh, lively translation of the ancient text remains truthful to the original concepts.

RICHARD ORTNER, my dear brother, has always been available to listen, edit, and encourage my ideas.

U TIN WINN, Ambassador from Myanmar, facilitated permissions and supported the project.

MYINT ZAW was truly the best guide in the world.

FREDDIE MAUNG OO offered his wide knowledge of Myanmar and provided personal contacts.

Great appreciation and respect is due the monks, temple trustees, and caretakers who allowed access, shared detailed knowledge, and taught us with their kindness and devotion. Many thanks to the local guides, drivers, and boatmen throughout Southeast Asia who made extra efforts to get us to remote locations safely and at the right time for photography.

155. THE PESHAWAR RELICS, Mandalay, Myanmar

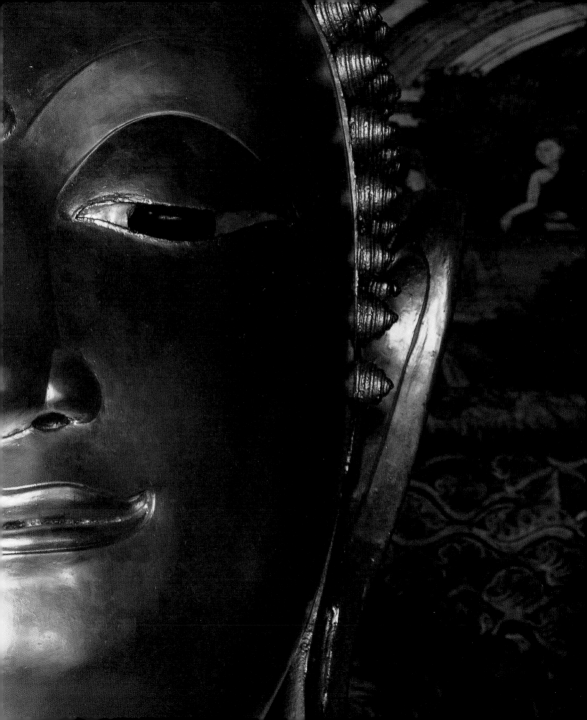

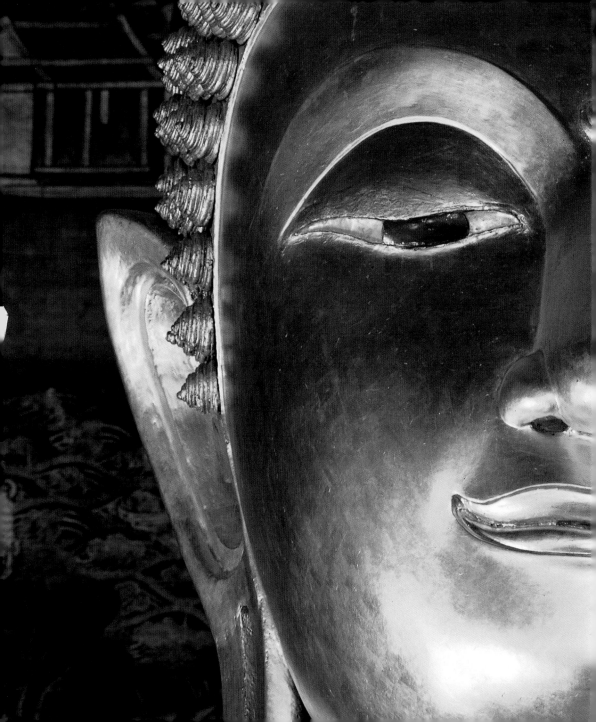

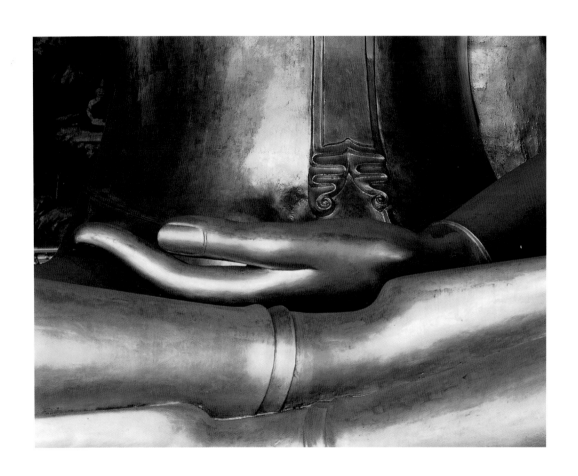

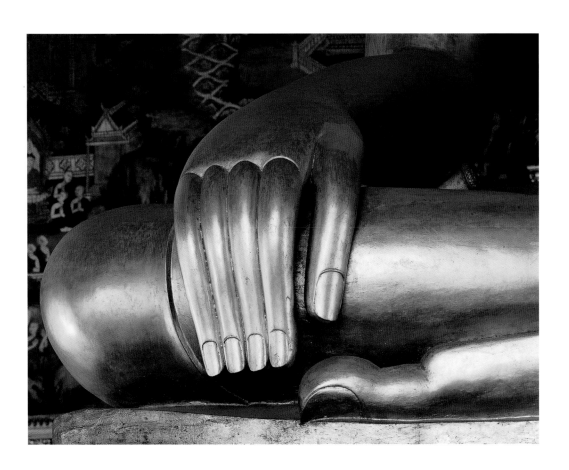

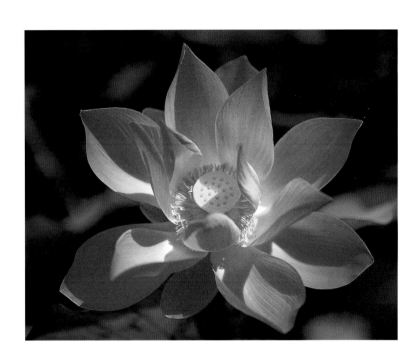